The Actor's Tool Kit

The Beginning Actor's Practical Guide to Acting

10/15

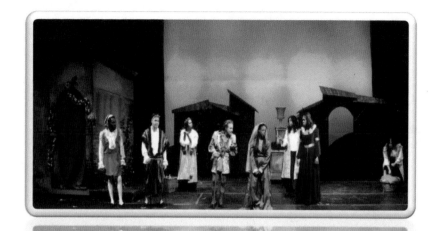

Taming of the Shrew by William Shakespeare
Adaption and music by Ardencie Hall-Karambe, Ph.D.;
Scenic Design by Petre "Teddy" Moseanu; Costume
Design by Ardencie Hall-Karambe, Ph.D.
Community College of Philadelphia, 2010

The Actor's Tool Kit

The Beginning Actor's Practical Guide to Acting

by Ardencie Hall-Karambe, Ph. D.
©2010

Cover photo: *One Flew Over the Cuckoo's Nest* by Ken Kesey. Directed by Ardencie Hall-Karambe, Ph.D. Set Design by Petre "Teddy" Moseanu; Costume Design by Rhonda Davis and Ardencie Hall-Karambe, Ph.D. Community College of Philadelphia, 2013.

Hall-Karambé

Dedication

This work is dedicated to my many students who, over the course of 20 years, have shaped my thoughts on acting, teaching acting, directing, and the theatrical business.

To my professors and classmates from Texas State University, Bobcat pride runs deep.

As with everything I do, my son is the purpose of my work.

Special Thanks

To my siblings and family for their continued support.

To my late-parents Clayton Hall and Blanche Marie Walker Hall, for their belief that we could succeed was everything.

3 1559 00255 7096

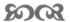

In my mid-20s, an actor told me, "Acting ain't no puzzle." I thought: 'Ain't no puzzle?!?'
You must be bad! You must be really bad, because it is a puzzle. Creating anything is hard. It's
a cliché thing to say, but every time you start a job, you just don't know anything. I mean, I can
break something down, but ultimately I don't know anything when I start work on a new
movie. You start stabbing out, and you make a mistake, and it's not right, and then you try
again and again. The key is you have to commit. And that's hard because you have to find
what it is you are committing to.
~Philip Seymour Hoffman

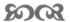

Acting is not about being someone different.
It's finding the similarity in what is apparently different, and then finding myself in there.
~Meryl Streep

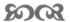

Table of Content

Introduction..8

Chapter One: An Approach to Acting—KIP Training®.......13

Chapter Two: Kinetic Training..28

Chapter Three: Influential Training......................................66

Chapter Four: Psychodynamic Training...........................89

Chapter Five: Theatre Terminology...............................110

Appendix...122

Hall-Karambé

"Lysistrata, Cross your Legs Sistah!" by Ardencie Hall-Karambe, Ph.D. Musical adaption by Ardencie Hall-Karambe, Ph. D. based on *Lysistrata*, by Euripides. Scenic Design by Petre "Teddy" Moseanu; Costume Design by Ardencie Hall-Karambe, Ph.D. and Rhonda Davis. Community College of Philadelphia, 2014.

Introduction

Let us start with this premise: *An actor is physically versatile and capable of quickly changing. An actor has excellent speaking skills, vocal flexibility, and a musical sense of language. An actor is a thinking and feeling individual who willingly plays the fool in front of others to express an idea or concept.* Now, with the establishment of this premise, I can explain the purpose of this book. *The Actor's Tool Kit* is an introductory manual for beginning actors. It introduces the concepts and ideas for KIP Training®, and how they can empower the actor's performance. My goal is for the text to serve as a guide to help the beginning actor improve and advance in his or her craft; student actors will find warm-up exercises and techniques useful to breakthrough bad habits or to discover some in-depth knowledge about a character.

This book is broken down into five chapters based on the subjects dealing with of acting theory as well as theatrical terms; it also has an appendix. The ideas is that each chapter focuses on a particular aspect of actor training; these chapters contain theoretical ideas that allow student actors to find freedom through theatrical experimentation and, thereby, through the process, prepare their voices, minds, and bodies for performance. It is important for student actors to gain a sense some of the history behind and innovators of the craft that they hope to turn into a career; hence, the need to include a brief explanation of the representational and presentational styles and those artists that promoted them. These artists left marks on the skill set and training of actors that continues to be practiced. Many of the ideas of KIP Training® are based on my understanding and interpretation of the theories put forth by them. As laid out here, it is clear that this text highlights the skills a student actor must learn in order to function when on a set and/or stage.

Hall-Karambé

Exploring the nature and components of acting are covered in Chapter One: An Approach to Acting—KIP Training®. This section gives students the theoretical means to gain actor's training by exposing them to techniques that allow them to explore and examine the use of their bodies, voices, and minds in ways they probably have never thought to do in public. What the actor does with these components is how characters are created, and, though many see it through the performance of the actor, most do not really understand how it works. This chapter helps student actors strip away the curtain to see the elemental ingredients of acting.

Chapters Two through Four examine the prep work an actor must do to develop and execute a very well constructed character in a play or film. The student actor learns to put the more esoteric aspects of acting into practical and tangible terms and notions in order to understand the particular complexity of the character he or she is playing. Beginning with the Actor's Pyramid, which represents benchmarks an actor can use to gage his or her progress in character development, to developing subtextual scripts, which an actor uses to understand what a character thinking, this section gives the student actors more tools to justify what they do as actors and why the characters do what they do in the play. These sections show the scholarship of the actor, for the actor must investigate the historical, social, and political aspects of the play as well as where, why, and how the character fits into that world. Student actors will create Character Development Forms and Character Observation Forms; they will delve into interpretation by Scoring Scripts basically doing what I call Actor's Homework. The idea is that the student actor will begin to "think like" the character he or she is playing.

Throughout the each chapter, there are warm-up exercises and games for students to practice with to gain confidence in that particular area and in their overall performance techniques. As students learn acting's theoretical ideas that form the crafts' building blockings, they must develop the proper lingo to communicate with others in the field. Chapter Five: Important Theatre Terminology covers the terms used in the industry that actors should know to work effectively and efficiently in theatrical settings as well as on film sets as many of the terms are interchangeable. It is rendered in the format of a dictionary for students' easy accessibility. There are also diagrams and other illustrations that will aid visual learners in clarifying some of the terms and notions.

As student actors advance, they are in need of places to continue their training and exploration of acting. The Appendix section of this book includes a list of plays that theatre art majors should have read by the time they are juniors in college. This section also includes other important ideas for beginning acting students to comprehend and incorporate into their collegiate and professional acting arsenal.

Many of the ideas in this book are not new but tried and true methods of discover. Theatre and acting are not easy; although, the artists make them appear so. Do not be fooled and swept into the glamour of the art form. There will be time for that later. Now is the time to think about the work ahead, for acting is hard work—as hard as any craft. See this book as an aid as you prepare your mind, voice, and body for the long road ahead.

Let the journey begin...

Hall-Karambé

ഇൻ

I regard the theatre as the greatest of all art forms, the most immediate way in which a human being can share with another the sense of what it is to be a human.

Oscar Wilde

ഇൻ

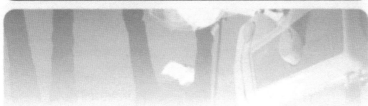

Chapter One:

An Approach to Acting—KIP Training®

For centuries, theatre artists at various turns have wondered, "What makes a strong actor?" In theatre programs across the country, theatre professors and theorists ponder, experiment, and explore the nature of acting and what makes an actor "strong." Students come into my studio or send email asking, "What can I be doing to make myself a better, stronger actor?" It is a definition that we all are searching for and on occasion some find. Acting is a craft; therefore, it can be learned, but the artistry of the craft is what is fleeting, difficult to teach, and so few understand. Strength, the desire to be stronger than where students are now, if you will, is what is being sought by teachers of the craft when preparing the student actors for performance and/or careers in this very difficult field. My desire as an acting coach is to prepare the actor to take the on the acting task ahead. Getting student actors to that place can be difficult, for they come with their own perceptions of what is acting and theatre. Weltanschauungs or worldviews will always come into play, but the key is to find tangible ways for student actors to gasp some of the larger concepts of the craft.

One of those concepts is the notion of being a strong actor. For my purposes here, I am defining "strong" as being mentally, physically, and emotionally capable to play a variety of characters. That notion of strong also harbors ideas of strength and agility both of the mental and physical kind. A strong actor must be in tune with his/her mental and physical processes, much like an athlete preparing for a race. Acting is akin to sport. Physical movement was important to the plays presented at the City Dionysia—a festival that celebrated Dionysus, the Greek god of wine, festivity, and theatre. Dionysus's love for party and play are clear, and we all know that music and movement/dance can make a party. They also echo of the ritualistic beginnings of storytelling practice. In ancient times,

Hall-Karambé

they were used to tell the story of the hunt, of creation, or of whatever the story required. With the establishment of the theatre festival in Greece, however, ritual became theatre competition. The music and movement of the chorus were specialized skills learned for competition purposes: cash prizes and bragging rights for the winners; these choruses moved as one and could number, at points in the history, up to fifty, thereby, making their need for precision essential. The city-states of Greece took these prizes seriously as seriously as modern football fans do the winners of the Super Bowl.

Acting is Sport

One basic KIP philosophy is that the training of the actor is similar to that of the athlete, dancer, or anyone who uses their bodies to communicate an idea and ideal. These activities require physical and mental endurance. Theatre performance is like a sporting event in the sense that actor like the athlete must be energized and aware of the happenings around them, and they must react accordingly; the world of the play or game is all that exist at that time. Actors train with a coach, as do athletes. Acting is a special skill, as are various sporting genres. There is a crowd cheering you on, and your opponent is the either an antagonist or a competitor. Actors are working as ensemble or a team to provide entertainment to patrons or fans. In the end, actors face the audience's cheers or jeers. Ah, there is the rub...

It is that moment backstage when everything is ready, when all the training is laid bare, and when rehearsal moves to curtain that our bodies and minds have ways of betraying us when we lest expect them too, and when they do, a crowd is (usually) around

to witness the meltdown. Let's hope it happens during rehearsal. How does either, the actor or the athlete, try to prevent such disasters from occurring less frequently? Before each sporting event, athletes run around the court or field utilizing practice drills, such as lay-ups or tossing and catching a ball, to warm-up their bodies and psych up their minds to prepare for the contest at hand. This action allows them to get the kinks out before the games and peps up the crowd. Actors, like athletes, have their rituals before performances; in many cases, they are privately done and unique to each actor, while at other times, the actor's warm-up is part of the larger ensemble or can be a combination of both. Every student actor, whether in rehearsal or performance, benefits from vocal and physical warm-ups, but many are resistant.

What are warm-ups? For our purposes, warm-ups are a series of physical, vocal, and mental exercises used as part of larger theatre training system or as a more concentrated preamble to an actual performance. The warm-ups techniques used in studio to train the actor are the same ones he/she uses as pre-performance drills. Warm-ups ease the body and mind into performance mode and the actor into character; they help to ward off nerves and/or stage fright. Yet, with these benefits, why do some actors resist warm-ups? Well, there are several reasons why some performers do not like to participate in warm-ups and most of the reasons stem from the performer's perception of himself/herself and his/her skills. Laziness, unpreparedness, reliance on past performance highs, and stresses from daily sources are some of the reasons actors give for not wanting to warm-up. I have witnessed countless performers, professional and amateur, who do not warm-up and find that the first few minutes of their performances often suffer. Later, they come offstage making statements such as, "The pacing is slow tonight" or "It is taking me a

while to get into character." What! Why are you onstage not in character? One of the requirements of being an actor is to be in character BEFORE going onstage. Just like the athletes who use their practice drills to prepare for matches, actors have theatre games, physical exercises, and vocal drills at the ready that prepare them for performances.

Why are they important? Warm-ups, according to studies, are vitally important to actor training and performance, for they sync the mind and body to work as one instrument. When used in studio, warm-ups drills and theatre games encourage student actors to stretch and strengthen the physical, mental, and vocal capabilities of their instruments; therefore, through the training, they flex their creative muscles building a foundation that they can utilize when acting. When done in a more concentrated manner, warm-ups help the student actor find control and be relaxed—before and during his or her performance—which permits a certain readiness to be in the world of the play. Experimenting through physical and vocal exercises and playing theatre games are an extensive part of the student actor's training as put forth in this text; I call this foundation training KIP Training©, which emphasizes the kinetic, influential, and psychodynamic nature of character development.

KIP Training© Program

The KIP Training© Program (KIP) emphasizes three training areas for the beginning and intermediate actor. These areas are kinesics, influential, and psychodynamic training.

Training Basics

Kinetic Training:	Students participate in physical movement using theatre games and warm-ups that aid and reinforce the use of the body

Hall-Karambé

in the creation character. Physical projection of character will be discussed and explored. Student actors practice different forms of physical training—yoga to Laban. The goal is to get the student actor in touch with their being in a way he/she may never have in the past.

Influential Training: A form of intuitive training, student actors practice the art of being perceptive to characters' innermost desires through the use of voice and diction. Student actors practice vocal dexterity and interpretation of monologues and scenes using the acting component of voice. Students must illustrate, vocally and descriptively on the text, that they understand the meaning of the creative pieces they are performing. The goal is to learn that the characters' emotional state influences vocal interpretations, which in turns influences the audiences' emotional reaction.

Psychodynamic Training: Students will write psychodynamic profiles for the characters they create and perform. The writing assignments will include developing a historical (GOTE sheet) map of the character. Psychodynamic is the interaction of the emotional and motivational forces that affect behavior and mental states of characters, especially on subconscious levels.

 As mentioned above, the student actor has several skills that must be trained in order to prepare for a life in the theatre. It stands to reason, thereby, mastering these skills is essential to becoming a strong actor.

The KIP Training© program encourages student actors to think of their own bodies and minds as "shells" for the characters they will be playing and also as the "tools" that help them to build characters. Stripping away is one of the main ideas KIP Training©; student actors are encouraged to dig deeply into the characters they create, while at the same time, they are encouraged to investigate themselves as artists in the process. It is interesting that student actors come into the studio "fully" aware of themselves, but when

asked to describe their own physical natures, they often miss something. Another example is when asked to look into their own eyes through a mirrored reflection; they find it difficult to maintain eye-to-eye contact with themselves. They want to take large sweeping looks of their complete images. This brings up one of the basic philosophical ideas of the training: that the student actor must know his/her own self to know where he/she and character are the same and where they are different. Character development involves the actor's complete instrument (body, voice, and mind); therefore, the student actors must strive to have clear views of themselves—externally and internally. Students are taught in the beginning of the training not to see the sum or whole of all the parts they are made but to see them as separate areas open to exploration as individual components that can be combined and configured in any number of ways to build character. Therefore, self-awareness observation is an intensive part of KIP, for student actors are asked to explore their own ways of seeing the world and their place in it on personal, local, national, and global scales at different times throughout the studio. The goal is that through self-awareness observations student actors begin to see themselves and others in non-judgmental ways. They learn to see their bodies not only as whole beings but also as parts that can operate independently or in concert together. By being conscious of the components that make us each unique individuals, student actors learn that by making different choices they change as characters. They gasp that differences between them and, let us say, Hamlet are not as widespread as they may have originally thought. Student actors must learn to see the universality of human beings in order to step into roles to which it seems they have no connection.

Hall-Karambé

Character building comes through the student actor's physical actions, vocal execution, and intellectual choices as he or she portrays and projects the character's conscious and unconscious mental and emotional processes thus illustrating the personality and behavior (psychological aspects) of the developed character that is seen on stage or screen. Through physical awareness techniques, vocal drills, theatre games, and script building exercises, student actors explore the various physical, mental, and psychological aspects of creating different characters with different personality traits. Thus, KIP Training© aims to give student actors foundational anchors that they can use to scale the Actor's Pyramid©.

The Actor's Pyramid©

One of the most difficult things to get student actors to understand about the craft of acting is the notion of intuition and how their intuitions can guide them to what "feels" right for their character. This quest happens during the rehearsal process. The student actors, in their experimentations to find characters, must dive into the pool of human universality where they play with different human characteristics based on clues given by playwrights and supported through the conceptual ideals of the director/acting coach. As the rehearsal process continues, student actors with the aid of the director/acting coach begin to narrow down the quality of traits that work for their interpretations of the characters.

However, many people don't trust their own intuitions nor know them to be real. Not real in the sense that one can touch them, but intuition is gut feelings, thoughts, notions

Hall-Karambé

that communicate instinctual instructions that at one time aided and guided our choices if we follow them. For example, our ancient ancestors used it daily in their survival amongst more predatory beasts; still today groups not part of the technological world exemplify this gift. Being able to communicate and converse with your intuition gives you the ability to see beyond your eyes, sort of speak, for you are looking at the possibilities of fate and the action of freewill at play. This is a liminal space where the invisible and visible worlds meet and mingle; it is a ritual place; it is a place of change, therefore, for many folks, it is not real thus making it harder to gasp. For those in technological societies, trusting one's intuition is a lost art; in most cases, the last people we do trust are ourselves! If it were otherwise, the world, I believe, would be a different place. Yes, we walk around all day, chest out beating on it like a drum, the confidence of a prize fighter in the ring, but the reality is for most of us it is an act that gets us through the day without allowing others to see us for who we really are; we suck in our guts, not taking complete breaths until hitting REM sleep, afraid to show our vulnerability to a world that seemingly honors only superficiality.

Trust is the foundational glue of theatre arts, for each artists, representing each artistic area that contributes to the production, must trust that everyone has the talents and skills to pull off the production, and that they are doing the work because a lot of theatrical work happens in specialized craft areas, at different times and paces, only to come together during technical week rehearsals. Trust is also important for the student actors. They must learn to trust their own intuition, but, for many, the idea is difficult. Therefore, these student actors need a tangible way of exploring and learning to trust their intuition when developing a character for performance. The Actor's Pyramid© is a

concrete (visible) way to get student actors to think about intuition, the process, and character development.

Figure 1:

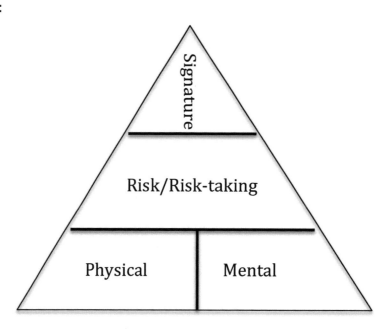

This diagram permits student actors to think about their work in the rehearsal process and character development as levels they must master to move to the next level. This visible image is meant to bring down from the ethers some of the more esoteric aspects of acting.

The Actor's Pyramid© is compose of four levels; each level represents a different skill the student actor must complete before moving to the next level. How will they know it is time to move? They will feel it! With directions and clues for each level, student actors can use the pyramid to build characters.

Level 1: Physical and Mental

This level is the pyramid's base—its bottom. Level 1: Physical and Mental represents the two types of actor's approaches to roles—the physical approach and mental approach. Divided into two sections, Level 1: Physical and Mental acknowledges the two types of beginning approaches to roles by recognizing the possible learning styles of student actors. It is here that student actors learn the foundational basics of character building that all actors must—learn the lines, blocking, intellectual quality and physicality of character—through the rehearsal process.

The Physical Approach Actor

These actors are physical or tactile. They want to wear the characters' physical traits like second skins. Stepping into and walking around in the characters' shoes permits these types of actors the opportunity to sense the world as the character through the physical first. They have a tendency to learn blocking and movement patterns quickly, and their characters usually are very physical in the beginning of the rehearsal process but tempered according to direction. They also need to spatial clarity; in other words, they need to "see" the room.

The Mental Approach Actor

These actors are mental or intellectual. They must understand and comprehend the psychological workings of the characters. "Why do they think that way?" They look for the driving force behind the

characters' thinking; they want to understand the mixture of nature and nurture in the characters personalities. Mental actors try to understand why characters make the choices they do. They are detectives on baffling cases that must be solved. They look for the clues through the character's diction or words of the playwright's notes. They have a tendency to memorize lines quickly, and often want to discuss the conceptual ideas. They question searching for answers in order for the world of the play and the characters to become "real" for them—mentally.

In either case, the two types experience the script and the process much like a puzzle that must be put together. Many student actors can find this difficult because, in my experience, they have not had to examine their own habits and others in such a fashion; however, they all can experience some hurdles in the process during various points in the training. The physical approach actor can get stuck in the physical and vocal experimentation portion of the process or mental approach actors can get stuck in their heads and never give their bodies the opportunities to play freely. Student actors find the merging of the spheres easier to do as they gain more experience; going forward, as they become more seasoned actors, they find circumstances when they may have to change their approaches to pieces based on script and production concepts. It is through the rehearsal process that student actors must strive to move away from their practical comfort zones to the opposite one:

Figure 2:

This action brings together the foundational elements—physical and mental aspects—of character. Human beings are mental and physical beings, with each area varying in degrees depending on the individual. Through the rehearsal process and the continuous use of drills as stated earlier, student actors remedy the seemingly rough transitional divide between the two areas. Once the student actors begin to feel a certain comfortableness, meaning they know the lines and blocking, and have begun their interpretation processes, they can then move to the next of the pyramid, which the level of risk or risk taking to be correct.

Level 2: Risk or Risk-taking

Possibility, chance, gamble, and venture are definitions of the risk; each one different but having an essence of its synonym; each word creates a different image in the mind, and yet each represents the student actors' work at this point. However said, Level 2: Risk/Risk-taking is the of level of more intense choices, a more in-depth search as to what works and what does not for the character as well as for the greater production. Because student actors are comfortable with the lines and the blocking at this point, they should begin to add substance to the characters by expanding on what they were already doing, finding new stage business, finding the musicality in line phrasing, and intensifying

Hall-Karambé

their interactions with other actors. When working with directors/acting coaches, student actors are questioned, prodded, pulled, and guided toward the actualizations of characters. Student actors, at this level, are putting into play their discoveries about characters, relations, and given circumstances. At this level, student actors should have strong idea of who their characters are and how they operate in the world of the play. The heighten intensity can shock student actors because they have never, in many cases, manifested this type of creative energy before—and now were doing it in public.

Vulnerability, although not a synonym of risk, is a part of the equation; risk-taking opens artists making them vulnerability to others who are viewing and critiquing their work. Learning to separate earnest artistic critique from personal attack is a task the student actor must practice at every turn. Learning to see vulnerability as a tool rather than a weakness is also a skill to master for the student actor. That openness is what permits the character to come through. The actor sacrifices, if I may, his/her own emotional and mental well being temporarily to allow another possibility of self to emerge. Much like the shaman in ancient rituals who cast aside their identities to permit the deity, god, orisha, or horseman to ride, the actor does the same in a controlled, scripted manner, which is, at the same time, spontaneous. This action harkens back to theatre's ritual roots.

Level 3: Signature

At the zenith of the Actor's Pyramid is Signature, which is where student actors can metaphorically sign their names to their renditions of characters. It is their personal acknowledgement of their struggles to make their performances unique. All actors work to bring exceptional qualities to their performances. After the afterglow of performance, an actor needs to critically examine his/her own work. This examination allows them to look

at the parts that worked and the ones that did not. Self-examination is neutral; it is an honest look at the work without personal self-judgment interfering. Being honest with themselves, being true to the craft and the work, knowing and acknowledging the rules, student artists decide if their performances are worthy enough to sign their name to history of a role.

In conclusion, the Actor's Pyramid is a visual guide to help student actors advance in their processes. It helps to put names to phrases in the rehearsal process that leads to performance in studio or in public. Let's face it most beginning actors do not enjoy the rehearsal process: "Why do I have to do it over and over again? I got this!" The repetitive activity begins to bore them because, in most cases, they do not feel themselves progressing in the process. This symbol aids student actors with that dilemma because it requires that they take an active looks at what they are doing at various points in the process. It enables them to formulate more tangible questions and, sometimes, even more complex questions to ask themselves or the director, while encouraging them to speculate and experiment with the various possible answers. This newfound knowledge allows them to gage whether or not they are progressing as the characters for themselves.

The last few pages have been an attempt to lay the theoretical seams of the KIP Training© method. The purpose was to give student actors and acting coaches a way to begin the conversation about theatre and acting theory. The following sections in Chapter One offer examinations into the theoretical threads of the system in an easy approachable manner. Part of the thinking behind this is that student actors need more in-depth understandings of the basic terms and ideas that inform the kinetic, informative, and psychodynamic natures of acting.

Hall-Karambé

...the body can provide a direct route to the emotions...
In every physical action, unless it is purely mechanical, there is
concealed some inner action, some feeling.

Konstantin Stanislavski

Chapter Two:
Kinetic Training

Kinetic Training: Students participate in physical movement using theatre games and warm-ups that aid and reinforce the use of the body in the creation character. Physical projection of character will be discussed and explored. Student actors practice different forms of physical training—yoga to Laban. The goal is to get the student actor in touch with their being in a way he/she may never have in the past.

The Kinetic Body

KIP Training promotes the notion of kinetic training for the actor because acting has a similarity to athletics in that actors use and want active responsive bodies, which is similar to that of athletes training for competition. But what is kinetics? Kinetics is the study relating to, caused by, or producing motion. As part of the training, the first 15 minutes of class or rehearsal should be spent preparing the body for the work ahead. Physical warm-ups are kinetic means by which student actors can train their bodies to perform at higher levels with a greater sense of artistry and grace. Warming up the body helps to be relaxed and ready to perform—whether in rehearsals or performances. Physical movement allows the mind to become free and open to possibilities because of an increased blood flow and a rising body temperature that causes the body and mind to fall into sequence with each other; they, therefore, work together to bring the total instrument—the actor's body—into harmony with itself. Student actors should add some form of physical warm-up to their per-performance routine in order to get the mind and body ready for play. There are many different types of physical warm-ups, but the main idea is that student actors are focused on discovering their bodies in new ways.

In sports medicine and kinetics, specialists view the body as regions that, although interconnected, can also operate as separate parts to produce individualized movements.

For example, our heads are connected to our bodies, yet we can move our heads and not move the lower half of our bodies; parts of our bodies can be isolated from the mass to create a particular physical response and/or silhouette. The moves used can be done either fast or slow and can be independent from other bodily actions; tempo is often determined by the rhythm of the music playing, by the delivery of the spoken word, the weight of the receiving object or person, and/or by pace of the participant's gait.

Kinetics training, the physical use of the body, offers ways for student actors to begin to engage with their bodies' natural impulses and to feel their bodily presence in a theatrical sense. Most people are out of touch with their bodies except when they are in pain or moving; even then, most movement is involuntary. We don't think about the action of walking once we have taken the initial step but ponder on where we are walking to—our destination. In truth, our bodies are storyboards for our lives; emotional and physical traumas stay on and within the body, often, taking up resident and manifesting in physiological and/or psychological ways. It stands to reason, therefore, that the actor's body through a heighten sense of physical action and receptive awareness must illustrate the emotional highs and lows as well as the actual corporeal journey of the character. If that is so, then, student actors should learn to be fearless in their bodies in order to experience the freedom to project the physical and emotional lives of the characters they play to audiences. The student actor does not have to the best physically fit body but be willing to allow himself/herself to explore different ways of being through that vessel. What kinetics training does is forces the student actor to look at the impulse to move and the body's muscular response to that impulse. Kinetics training, in this context, looks at the body and the body in motion; it explores how physical actions and reactions are important

interpretive tools of characters' physical and emotional states of being. In this case, it is the study of how actors use movement off-and-on stage to prepare and present roles. KIP Training© begins with the body because it is most the immediate way to connect with the mind, for a relaxed body makes it possible to perform freely. The idea is that when we become more in tune with our physical selves, we can become more in tune with our emotional and psychological selves.

Physiology of the Body

The body is a complex design. It was created for movement, and the more the gift is used the better it performs. Like any skilled artists and their well-tuned instruments, actors used their highly receptive physical skills at superior levels to bring out the internal impulses of the characters they are playing. However, not many student actors know much physiology. By understanding the body's composition and make-up, student actors gain a stronger sense of how the body can be manipulated to create character.

The body has a foundation of bone that is held together with ligaments, cartilage, and muscle all incased in skin. The joints, the areas where the appendages and torso meet, are hinge-like mechanisms that allow the body's appendages—legs and arms—to create straightened, rounded, angled, and disjoined forms of stillness and mobility. The imagery of graceful dancers bending and lifting their arms to form sublime lines of movement or of energetic children flinging and flaying their, seemingly dismembered, limbs only to freeze suddenly in a game of "1-2-3-red light" illustrating their joy of play makes clear the wide variety of shapes the extremities can display. The mainframe or torso houses the vital organs that are protected by the bones of the ribcage. Fused to the ribcage at the sternum

or breastplate, in the front of the body, are the collarbones; they are also fused to corresponding shoulder blades in the back. These are connected to the arms. The back of the ribcage and the shoulder blades are then joined to the backbone or spine, which runs in both directions—south meeting the pelvis and hip bones and north joining with skull. The spinal cord threads through the bones aligned in the center of the back, and it runs the complete length transmitting neurological jolts from the brain to the rest of the body giving the commands to function. It is important to protect the spine and the back from injury. The body is a well-constructed machine that needs to be fine-tuned to operate properly. One way of doing this is to institute physical warm-ups into student actors' routines before rehearsals and performances.

ಬಿಂದ

We stand without knowing how...
We are thus not aware of any effort or activity in
the muscles that work against gravity. We
become aware of the antigravity muscles only
when we either interrupt or reinforce them, that
is, when the voluntary change is made in clear
awareness.

Moshe Feldenkrais

ಬಿಂದ

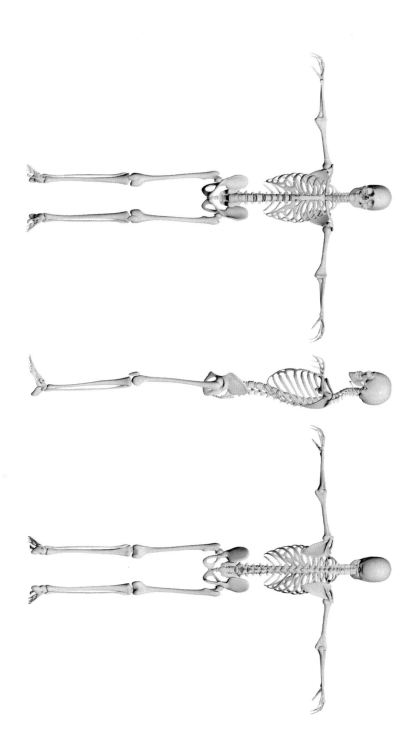

Muscular composition of human body

The Basics Kinetics: Alexander, Feldenkrais, and Laban

Movement is a language that is open to interpretation and description, and centuries of human evolution has allowed us to create unconscious sensitivities to physical positions thus making much of body language's meaning instinctive. For example, if you come into the room to find your mother standing with her hands on her hips (arms akimbo) with her right foot patting and her face skewed, you pray you are not the object of her rage. Most of us, however, don't consciously listen to or even think of our bodies unless we are in pain or in training. We are unconscious to our physical consciousness. Understanding human movement, nevertheless, is essential for the student actor because through movement they become aware of themselves as physical and emotional beings.

Frederick Matthias Alexander, Moshe Feldenkrais and Rudolf Laban were pioneers in the area of kinetics. All entering the arena for various reasons: Alexander was an actor with chronic vocal ailments; Feldenkrais had an injury that left him unable to walk; Laban was a choreographer wanting to preserve dance sequences. Their ideas, however, have connective points that are useful to student actors. Beginning with the notion of a neutral body, including the corrective aspects, and then ending with the transformative nature of movement, their styles and approaches differ but their message to the student actor is still the same—To act is to move.

The body is meant to move, and most people do so without thinking about it. For the actor thinking about the body and how it is used is important because the body is the instrument by which the actor shapes, plays, and displays their creative product. It is their canvas and like canvas it must be clean and free, opened to that first brush stroke. The student actors' learn to examine their own movement and, "correct" their physical issues in

Hall-Karambé

order to find a neutral body or as Konstantin Stanislavski puts it in *Building a Character,* a "clean canvas" upon which to paint a picture. Like the blank canvas, a neutral body is a receptive body as well. Consider, how does the student actor begin this process? It becomes important for student actors to become aware of themselves as agents, and, by doing so, they gain some needed insight into their physical action abilities and traits. However, most student actors have no clue to their everyday movement patterns: What are their hands doing when they walk? What is happening with the feet? Where does the movement start in the body?

The first step in neutral body discovery is to observe one's own body in movement. When striving for the neutral body, the student actor will utilize moves that permit them restore their natural movement patterns thereby removing poor alignment habits that are often seen as *natural* but are the results of physical and psychic traumas.

Practicum 1:

Personal Alignment Discover

To discover your personal alignment here are several exercises you can perform:

- Stand in front of a mirror and, without placing judgment, observe how you hold your body, head, and shoulders. (Are you knock-kneed or pigeon toes? Do you lean forward or backward? Do you lean to the side?) Turn to the side; look at yourself taking in your alignment from head to foot. (Do you hyperextend your knees? Do you tilt your shoulders or pelvis? Do you crane your neck?

- Have a partner observe (from multi-direction) you walk across the room. They should make notes on your movement. (What are your arms doing? Do you walk with your head up? What is happening with your shoulders? Knees? Feet?)

- Again with a partner, you should do simple everyday task. (Sit in a chair, walk up the stairs, etc.) What happens to your alignment when do these things?

unlearning improper habits of posture, movement, breathing and body orientation, and replacing them with fluid movement that is tension free. Alignment of the body is at the heart of and vital to neutral body discovery, but what is alignment? Alignment refers to arrangement of the skeletal and muscular system in an efficient and balanced order; if the body is not in alignment, it holds tension and causes the whole body as well as performance to be affected. There is no perfect alignment; it varies, as does human beings. Understand, for our purposes, that this is about stripping away of old habits and notions to find a new foundation upon which to build character. Therefore, the actor's body becomes the incubator from which characters spring forth. The training produces a skill set that can be applied in every performance situation and leaves one feeling lighter, more grounded, and free of tension in movement and speech.

Discovery for the neutral body is done, in most cases, with a group of other acting students, but it is an individualized search as well. An actor must set aside his/her own ego and allow the *ego* of the character to step forth and claim possession of the body. Only with a neutral body is this possible. This undertaking of possession is taxing on actors on several levels. As they mature and grow in their craft, the physical demands of the roles change and their interruptive skills sharpen; therefore, the need for neutral bodies is even more imperative because they are not only the places to beginning crafting more complex characters but become places of rest for actors allowing them to reconnect with their own sense of self. Therefore, the actors' search for neutral bodies is ongoing. It is a journey of discovery that happens externally, moves internally, and back again. The trip begins with isolations because looking at the movement of separate body parts and their relationship to one another enables us to recognize the body's structure and organization. Isolations give

students the means to understand their own physical preferences, while developing a certain amount of objectivity when observing movement patterns of others.

Practicum 2:

Warm-up Exercises, Yoga, and Chakras

The following is a sample list of movements covering the major areas of the body. Also, there are other simple physical maneuvers listed as well that will help student actors begin the process of learning to manipulate their bodies to create characters. This sample list of moves comes from a variety of physical disciplines including Alexander Technique, Yoga, Feldenkrais Method, and Laban Method. Student actors will use these movement methodologies to train their instruments in order to not have them rebel—in the form of nerves, stage fright, and uncontrolled movements or flicks—in performance.

Isolation Movements

Isolation movements are just as they imply—isolated movements. The student actors will move only that particular part of the body at that time. Remember, when working a specific region concentration on that area is important for success; therefore, student actors need to take notice of the muscles, bones, and ligaments used to make that isolation happen.

- Full body stretch (reaching for the sky) and contraction (bowing to touch your toes)

- Head/neck tilts and rolls

- Shoulders (lift up/drop down; roll forward and back; alternate sides)

- Upper torso (expand and contract the ribcage; thrusting forward and side-to-side)

- Hips/pelvis (thrust forward and back; shift right and left; circular rotation)

- Feet and Ankles (flex and point toes; circular rotation)

- In the curled position, bend the knees gently; let the body bounce

- Marching in place (variations: Side steps, Knees up, Forward kicks, Kickbacks)

- Soul Train Line (It is not about fancy dancing but being able to find and keep a beat using any physical movement.

- Sporting Champions (Students must perform the action as if they are in the game at that moment.)

- Sound and Movement Wheel (variations: 'Tells Us Your Name'; Memory Thread)

- Zip, Zap, Zop! (This game warms up the body and voice.)

- Futuristic Machines (A variation of Sound and Movement Wheel. One student starts the action of a repetitive sound and movement; other students (the other machine parts) are added to complete the machine. The group doesn't need to be large.

Beginning Yoga Poses

Basic yoga poses are great ways for student actors learn about movement, breath, and stillness. Yoga is great for the core and for alignment, which aids in breathing. These is only few; there are many more that are useful to get student actors thinking about their bodies as instruments they must train to work effectively and affectively.

Cat-Cow Stretch (*Chakravakasana*)

Cat-Cow is a great beginning yoga pose. It is a wonderful move for back pain. Stretching this manner aids spinal health by reliving pain and offering improved flexibility.

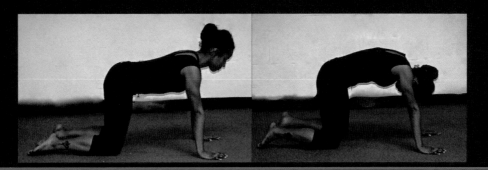

Mountain Pose (*Tadasana*)

Mountain pose is an important pose because it offers an opening to discussing alignment, which is the way body parts are ideally arranged in each pose. The alignment in mountain pose draws a straight line from the crown to heels, with the shoulders and pelvis stacked along the line on the way down.

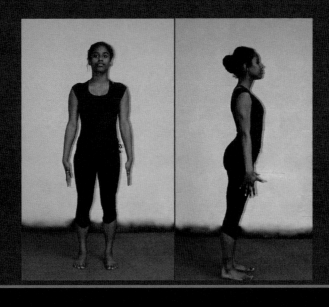

Cobra *(Bhujanga)*

Lie prone on the floor. Stretch the legs back, flexing the feet until the tops touch the floor. Spread hands on the floor under your shoulders hugging the elbows tight into the body. Pressing the tops of the pubis, thighs, and feet firmly into the floor, inhale while straightening the arms to lift the chest off the floor, going only to the height at which a connection can be maintain from the pubis through to feet. Press the tailbone toward the pubis and lift the pubis toward the navel narrowing the hip points at the same time. The buttocks are firm not hard. Bring the shoulder blades closer against the spine, puffing the side ribs forward. Lift through the top of the sternum but avoid pushing the front ribs forward, which only hardens the lower back. Let action feel as it if is starting at lower ribs and going outward which natural rise with inhalation. Distribute the backbend evenly throughout the entire spine. Hold the pose anywhere from 15 to 30 seconds, breathing easily. Release back to the floor with an exhalation

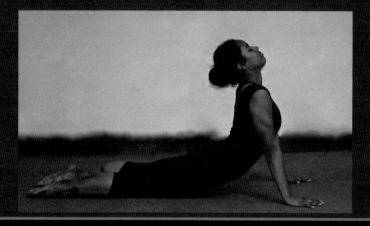

Downward Facing Dog - Adho Mukah Svanasana
This is resting pose; although, it is not an easy move. Some shift themselves too far forward in this posture, making it more like a plank, so try to remember to keep the weight mostly in the legs, the butt high, and the heels reaching toward the floor. Bending the knees a little or a lot is an accepted modification for people with tight hamstrings. Eventually, this pose becomes a resting posture. Believe it!

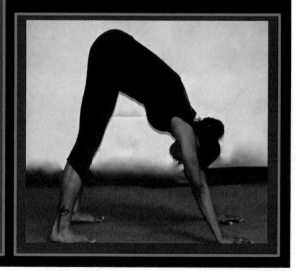

Triangle Pose- (Utthita Trikonasana)

This is a standing pose that strengthens the legs, stretches the groins, hamstrings, and hips, opens the chest and shoulders, and can help easy back pain. Starting in the Warrior II pose, you straighten the front leg. Reach with same arm that is with the front leg towards the front of the room, engage the thigh in the reach and lean. Drop the reaching hand down onto the shin or ankle. If more open (limber), bring the hand to the floor on the inside or outside the right foot. Do whichever one feels most comfortable.

Stack the shoulders while opening the chest, reach with fingertips towards the ceiling while keeping the upper shoulder rooted in its socket. Keep your head and eye turn up toward the upper shoulder. Take the hinge in the hip little deeper.

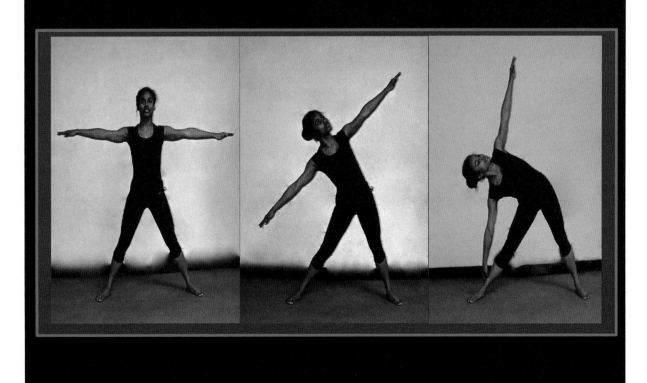

Warrior Series

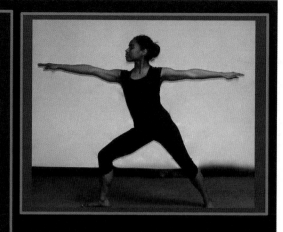

Warrior I - Virbhadrasana I

The important thing to remember in Warrior I is that the hips face forward. Think of the hip points as headlights. They should be roughly parallel with the front of the mat. Sometimes this requires moving the legs into a wider stance (towards each side of the mat).

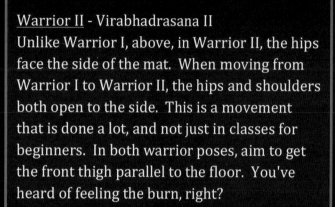

Warrior II - Virabhadrasana II

Unlike Warrior I, above, in Warrior II, the hips face the side of the mat. When moving from Warrior I to Warrior II, the hips and shoulders both open to the side. This is a movement that is done a lot, and not just in classes for beginners. In both warrior poses, aim to get the front thigh parallel to the floor. You've heard of feeling the burn, right?

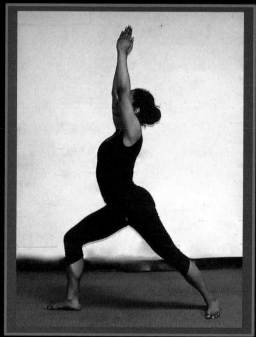

Warrior III – Virabhadrasana III

Begin standing in Mountain Pose with the feet hip-distance apart with arms by sides. Turn to the left stepping wider apart, about 4 to 5 feet. Turn the right foot out so toes point to the top of the mat. Pivot left foot inward at a 45-degree angle. Point pelvis and torso in the same direction as the right toes are pointing. Bend the right knee the right ankle so the shin is perpendicular to the floor. Raise the arms overhead with palms facing each other. This is Warrior II. Press body weight into the right foot. Lift the left leg while lowering the torso, bringing the body parallel to the ground.

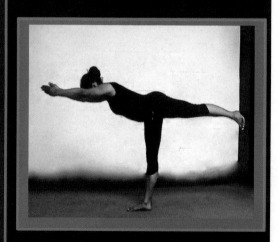

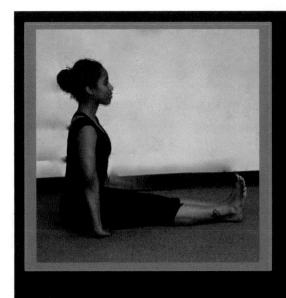

Staff Pose – Dandasana

Staff pose is the seated equivalent of mountain pose (above), in that it offers alignment guidelines for a host of other seated Sit on a folded blanket or two if having trouble sitting up straight with the butt flat on the floor. Oftentimes this pose leads into a forward bend.

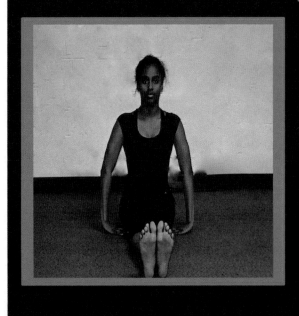

<u>Cobbler's Pose</u> - Baddha Konasana
It can also be a good idea to sit up on something like a blanket in cobbler's pose, especially if the knees are way above the hips in this position. Since we rarely sit this way in our everyday lives, this pose stretches some neglected areas of the body.

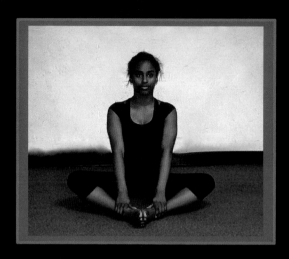

<u>Child's Pose</u> - Balasana
Child's pose is really important. It's the position one can assume any time in need of a break during a yoga class. If feeling light-headed or overly fatigued, don't wait for the teacher to call for a break. Just move into child's pose and rejoin the class when ready. It's all you, baby.

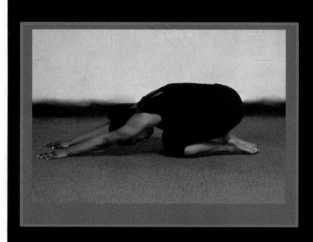

These yoga poses, plus others, can aid the student actor in understanding how the body is a highly specialized machine that can be trained to respond on the slightest of impulse.

Hall-Karambé

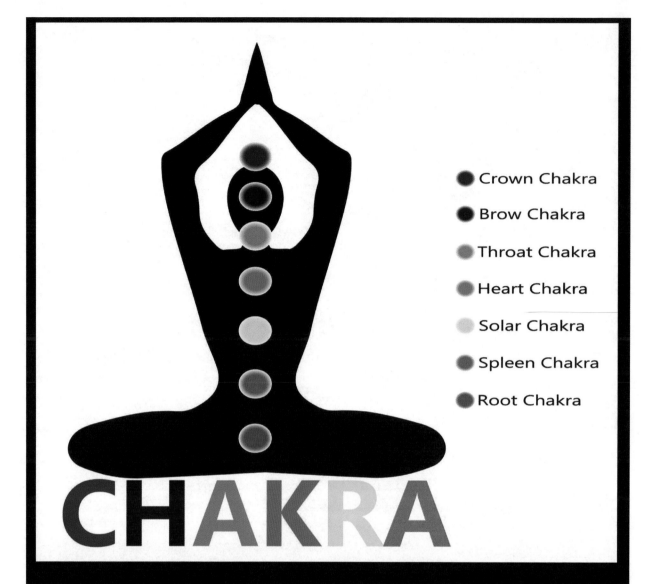

Crown Chakra
Brow Chakra
Throat Chakra
Heart Chakra
Solar Chakra
Spleen Chakra
Root Chakra

CHAKRA

The Chi of Acting (Art and Living)

ഇരു

Without wonder and insight, acting is
just a trade. With it, it becomes creation.

Bette Davis

ഇരു

Coming from Eastern thought, chakras are circular energy regions in the body that align along the spine, from its base to the crown of the head. Chakras are areas where matter and consciousness meet and give off an invisible energy called Prana, which translates to mean breath or breathing. It is a vital life force, which keep us vibrant, healthy, and alive. Physiologically, these swirling disks of energy correlate with massive nerve centers in the body. The centers not only house nerves but major organs and correspond to our psychological, emotional, and spiritual states of being.

Chakras, in the acting process, act as portals from and to the energy centers in the body. Energy flows in and out of them unless they are blocked. With the constant flux of the body between balance and imbalance, it is important to keep these areas open, clear, and unblocked. One-way of doing this is through awareness; awareness is key to aligning them. When they are blocked, your awareness as actor and your ability to create character are diminished. By unblocking and aligning the chakras, student actors gain a greater sense of themself in world and their characters have greater depth for their creativity and imagination would be free to explore previously obtruded pathways and access emotions effortlessly. Much of the work—isolations, yoga, and alignment—in studio is about building awareness, and chakras are activated through the process.

The following definitions give a description of the chakras and their functions, colors, and musical notes.

Root or Base Chakra

Color Association	Red
Location	Base of spine,
Lesson physical	Survival–The right to exist. Deals with tasks related to the material and world. Ability to stand up for oneself and security issues
Musical Note:	C

Spleen Chakra

Color Association	Orange
Location	Below navel, lower abdomen
Lesson related	Feelings—The right to feel. Connected to our sensing abilities and issues to feelings. Ability to be social and intimacy issues.
Musical Note:	D

Solar Plexus Chakra

Color Association	Yellow
Location	Above the navel, stomach area
Lesson ego	Personal power–The right to think. Balance of intellect, self-confidence and power. Ability to have self-control and humor.
Musical Note:	E

Heart Chakra

Color Association	Green
Location	Center of chest
Lesson have	Relationships–The right to love. Love, forgiveness, compassion. Ability to self-control. Acceptance of oneself.
Musical Note:	F

Throat Chakra

Color Association	Blue
Location	Throat region
Lesson beliefs	Relationships–The right to speak. Learning to express oneself and one's (truthful expression). Ability to trust. Loyalty. Organization and planning.
Musical Note:	G

Brow or Third Eye Chakra

Color Association	Indigo
Location	Forehead, in between the eyes
Lesson negative	Intuition–The right to "see." Trusting one's intuition and insights. Developing one's psychic abilities. Self-realization. Releasing hidden and repressed thoughts.
Musical Note:	A

Crown Chakra

Color Association	Violet
Location	Top of head
Lesson	Knowingness–The right to aspire. Dedication to the divine consciousness and trusting the universe. Learning about one's spirituality. Our connection to the concept of "God" or a higher intelligence. Integrating one's consciousness and sub-consciousness into the super-consciousness.
Musical Note:	B

What are blockages in the chakra? Blockages vary; blockages can appear as a sinus headache effecting the Brow chakra or as heavy menstruation period tormenting the Root chakra. Granted they appear as physical ailments, but some appear as roadblocks to progression as well. Meaning: we often sabotage ourselves. Either manifestation is counterproductive. Kinetic techniques will open the chakras easing physical and mental tension, which can be a major player in pain and disease. To counteract these blockages, good alignment and breathing techniques must be applied in studio, rehearsal, and performance. Moreover, playing music in the key that correlates with the musical note for the blocked chakra has been found to help bring it back into balance.

Most people don't live in the moment. They are caught in past memories or dreaming about the future. Why is that? Frankly put, living in the moment is exhausting. Being present, awake and aware, is tiresome. When awake and aware, people experience the world in a heighten state of being because everything is turned on and open to experiencing life, and it can become overwhelming. For the actor being present while on stage is vitally important to what they do on stage. The actor must be awake and aware of what is happening around them at all time. A neutral body allows them to convey the sensations, feelings, thoughts, and movements (actions) of the characters they portray as if they really happening for the first time. When we are awake, we experience sensations, feelings, thought, and movement; they are how we understand the world around us. For clarity, Feldenkrais defines them as:

1. Sensation includes the five senses, the kinesthetic senses, which includes pain, orientation in space, the passage of time, and rhythm.

2. Feelings are familiar emotions of joy, grief, anger, etc., while including self-respect, inferiority, super sensitivity, and other conscious and unconscious emotions.

3. Thinking covers functions of intellect, such as opposition of right and left, good and bad, right and wrong; understanding, knowing that one understands, classifying things, recognizing rules, imagining knowing what is sensed and felt, remembering all the above, and so on.

4. Movement is all temporal and spatial changes in the state and configurations of the body and it's parts, such as breathing, eating, speaking, blood circulation, and digestion (31-32).

In the context of theatre, these four components are essential for the student actor to understand and to comprehend because they are the primary ways human beings function and experience in the world and, thus, can be used as the building blockings of character creation.

Since this chapter deals with movement, it is necessary to take a moment to examine and expand upon the component of movement, for movement ignites the other three components—sensation, feeling, and thinking—into action. Through and with movement, the actor provokes and transmits sensory (sensation), feelings (emotion), and thought (thinking) to an audience. In a classroom setting, it is much easier for student actors, at the beginning of their training, to understand and display movement than it is the other factors. Society does not encourage public displays of emotion nor can it be said that most are thinking or sensing the world around them at all times. It is simple to look around and see the chaotic environment that exist and believe that non-thinking or sensing individuals, who care little for their fellow beings, run it. The animalistic nature of humankind served well at during a time when people were more animal than human—a time when language had yet to form. In order to survive, people had to learn to read the body language of an approaching individual as it moved through gravity and space. Their very survival depended on it! Were they friend or enemy? Hence, the experience human beings have with movement is greater and deeper than we know or think about on a conscious level. People are meant to move, and indeed, most have better capacities to understand it than they do feelings or thoughts. For this reason, human beings, it should be stated, gain a sense of self-awareness through movement.

Most think of movement in bigger, more invigorated terms, but all muscular activity, even the most minute, is movement. Every action originates in muscular activity. Seeing, talking, and even hearing all require muscular action. In hearing, for example, the muscle regulates the eardrum's responsiveness in accordance with the volume of the sound received. For the student actor learning to perceive of his/her body as energized and active with a heighten sense of awareness, he/she conscious aims to hear the verbal stimuli and, through active-listening, reacts to the volume (and ideas) received. He/she feels, if you will, the rhythmic words beating on the eardrums and reverberating in the ears' cavernous cavities. This small physical action of the eardrum is only one part of the mechanical coordination of movement throughout the entire body. In larger parts of the body, movement finds meaning partly through the emphasis (weight) given to the motion, which is dependent upon the inner impulses (feelings/thoughts) of the character. Therefore, the dynamic aspects of movement change depending on inner involvement and personal preference.

Movement is also governed by temporal and spatial conditions as well. Having an accurate sense of time and space is important to knowing the intensity needed for any given movement. For example, lack of muscles use causes, over time, action to be slow (time) and rounded (space), while excessive muscle use causes actions to be fast (time) and angular (space); both extremes clearly frame the mindset of the individual exhibiting them and are linked with the motives of the action. For example, people, for the most part, are conditioned to operate properly in the room (space) they are residing and their actions (movement) are often dependent on the moment and/or day (time). In other words, the way you behavior in a bathroom is different than the way you behavior in a kitchen,

Hall-Karambé

thereby, making your actions different as well. Some actions, such washing of hands, can take place in both rooms but most action is dictated by the space. However done, the action's consistency (flow) is appropriate for the situation at hand.

Movement's weight, space, time, and flow determine how it is read by an audience when the actor delivers it. The action's intent is concluded by the dynamic energy used by the actor. Remember that each—weight, space, time, and flow—has extremes; each extreme has opposing directional forces.

- Weight: Strong / Light
- Space: Direct / Indirect
- Time: Sudden (or Quick) / Sustained
- Flow: Bound / Free

Weight, space, time and flow combined with what Laban called "effort actions" or "action drives" can be put into numerous combinations that would result in a wide variety of physical expressions. The eight effort actions are descriptively named Float, Punch (Thrust), Glide, Slash, Dab, Wring, Flick, and Press and are the bases of all movement. This chart illustrates the coordination of the efforts with time, space, and weight.

EFFORT	TIME	SPACE	WEIGHT
PRESS	Sustained	Direct	Strong
FLICK	Sudden	Indirect (flexible)	Light
WRING	Sustained	Indirect	Light
DAB	Sudden	Direct	Light
SLASH	Sudden	Indirect	Strong
GLIDE	Sudden – Sustained	Direct	Light
THRUST (PUNCH)	Sudden	Direct	Strong – Light
FLOAT	Sustained	Direct – Indirect	Light

These effort actions are used to train the actor to sharpen their ability to change quickly between physical manifestations of emotions, create and describe character movements, explore how objectives can be physicalized in action, and to experiment with unrelated movements in an effort to pair movement with character personality.

Weight, space, and time are held together by flow and phrasing. Flow is responsible for unhindered steady movement, eloquent expression of thoughts, and shape change under pressure. Without any flow effort, movement would be contained in a single initiation and action much like the jerky motion of a robot. In general, it is very difficult to have movement without flow.

ഇ)രു

...that part of the inner life of man where movement and action originate.

Rudolf Laban

ഇ)രു

Flow is the glue connecting the physical actions into a visual storyline and is also strongly connected to personal space (kinesphere) and shape. This is not the same notion of space, as mentioned before, but space as the immediate area that surrounds one's person. It is personal space that, according to Laban, is discoverable using geometric pathways—angles and lines—that challenges us to move in ways we don't normal move. Movement is seen in terms of being 3-dimentional. During the training process, the student actor should employ basic geometric shapes as guides to exploring as many possible movement points around their personal kinesphere letting flow connect those motions together. With each flowing movement, the shape of the body changes in relation to itself and its surroundings. Humans make contact with or withdraw from our environment by changing our body's shape and direction. In other words, our

body's shape changes are linked to aspects of space through attractions and detractions. Phrasing is the grouping or combination of moves. With phrasing in movement (with reference to the four aspects that were already mentioned), we can discern the characteristic patterns of a character's movement. This is the way in which a character structures and stresses a movement. With a bit of practice, this individual pattern can be observed clearly. Through the use of flow and phrasing, the body is a strong nonverbal component of communication.

Practicum #3:

Subcategories in Shape

- "Shape Forms" describe static shapes that the body takes, such as Wall-like, Ball-like, and Pin-like.

- "Modes of Shape Change" describe the way the body is interacting with and the relationship the body has to the environment.
There are three Modes of Shape Change:

1. Shape Flow: Representing a relationship of the body to itself. This could be amoebic movement or could be mundane habitual actions, like shrugging, shivering, rubbing an injured shoulder, etc.

2. Directional: Representing a relationship where the body is directed toward some part of the environment. It is divided further into Spoke-like (punching, pointing, etc.) and Arc-like (swinging a tennis racket, painting a fence)

3. Carving: Representing a relationship where the body is actively and three dimensionally interacting with the volume of the environment. Examples include kneading bread dough, wringing out a towel, avoiding laser-beams or miming the shape of an imaginary object. In some cases, and historically, this is referred to as Shaping, though many practitioners feel that all three Modes of Shape Change are "shaping" in some way, and that the term is thus ambiguous and overloaded.

- "Shape Flow Support" describes the way the torso (primarily) can change in shape to support movements in the rest of the body. It is often referred to as something that is present or absent, though there are more refined descriptors.

- "Shape Qualities" describe the way the body is changing (in an active way) toward some point in space. In the simplest form, this describes whether the body is currently Opening (growing larger with more extension) or Closing (growing smaller with more flexion). There are more specific terms - Rising, Sinking, Spreading, Enclosing, Advancing, and Retreating, which refer to specific dimensions of spatial orientations.

The main idea of kinetics is that human beings' primary basis of awareness, in essence, is through movement and that human beings experience the world through and by movement. Most people are unaware of their physical being until an impulse hits the muscles, and they begin to move aligning themselves in familiar patterns until, finally, stabilizing into a position. People become aware during those changes in their physical stance, stability, and mindset; it can be recognized as either a physical, mental, or emotional shift; for most everyday occurrences, it is a combination of two shift types but, at other times, full awareness is demanded. Acting is one of those times that full attention is given to the task at hand. The actor must have a heighten sense of what is happening physical on every level and through every sense. Acting is kin to the ritual process where everyday activities and objects become significant in meaning. When creating a character, it is the actor's art to bring that elevated awareness into play. The character's awareness or perception of being is discoverable through the actor's gaged movement through gravity, and, in accordance to, the given circumstances of the play. Student actors must unhinge

their everyday movement patterns as well as their everyday thought patterns to discover character possibilities. Basically, by changing the way the actor moves can change the way he/she thinks, and, ergo, opens him/her to character development. The actor breathes life into a character, as breathing is movement. Conscious breath is being aware of every shallow and deep emotional undercurrent and impulse being experienced. Breath's connection to emotional states of being are part what that the actor must explore during the course of rehearsals and exhibit in performances. A good time to work on it is during the yoga and isolation portion of the warm-up; try actively joining breath with movement letting them ebb and flow together.

Thus far, the chapter has been about individual movement. Yet, on stage the actor must often work with others. It becomes important, therefore, to explore the nature of physical relationships on stage. How does one share the stage with other people and objects? Whether people (two or more) have a conversation, dance, walk or eat together - they always position themselves towards, next to, or away from one another. Depending on the relationship between the characters and situation of the scene or play, the relationships between characters will vary but characteristics of those relationships are expressed in movement. Movement relationships on stage illustrate the interactions

- of people

- of different body parts to one another

- and the relationship of objects and people.

Hall-Karambé

The varying distance and motion patterns between the different characters and/or objects created by actors are used to interpret relationships. The relationship between characters is clearly defined in movement: for example, in the opening scene of play, the one character supports another by hugging or holding him/her. However, in the next scene, the same character still wanting to show support is pushed away and held at a distance by the other character, therefore, making the active part of this relationship change.

For the student actor: remember that observation is a major tool of the actor and when watching people move through space, note how their bodily actions are illustrations of the nervous system's health because all movement simply put is the product of impulses sent through the nervous system from the brain. In truth, no physicality including voice can be changed without a change in the nervous system that marshals the outward visible and vocal changes. In other words to change the way you think, you should change the way you move and operate. Kinetics aids in giving the dynamics to performance.

ℰᴑ℘

The astonishing structure of the body and the amazing actions it can perform are some of the greatest miracles of existence. Each phase of a movement, every small transference of weight, every single gesture of any part of the body reveals some feature of our inner life.

Rudolf Laban

ℰᴑ℘

On Stage: The Body Terminology

Body Positions

Eight body positions are designate for the actor in relation to the audience. All positions

are designed by the degree to which the actor faces the audience. These are used when

acting alone or with another actor. (See chart)

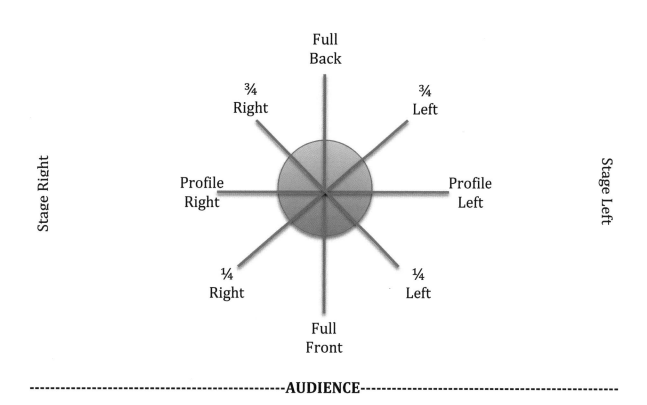

For proscenium staging, these eight body positions are all used but try to avoid delivering

too much back to the audience. Arena staging offers the opportunity to put all of these into

use because there is audience on all sides.

Note: Profiles right and left are also referred to as half right or half left.

Hall-Karambé

Open: A position in which the actor is facing toward the audience or nearly so. To *open up* is to turn toward the audience. Since effective communication requires that the actor be seen and heard, he must—without sacrificing believability—keep himself as open as possible. Although there are many exceptions, you should *follow these practices* unless a reason exists for to do otherwise:

1. Play shared scenes in a quarter position.

2. Make turns downstage.

3. Do not upstage or cover yourself or other actors while making gestures or passing objects. In other words, use you upstage arm.

4. Kneel on the downstage knee.

Closed: A position in which the actor is turned away from the audience. To *close in* is to turn away from the audience.

Actor's Positions in Relation to One Another

Actors' positions in relation to one another are considered with regard to the relative

emphasis each actor received (see illustrations).

Shared: When two actors are both *open* to an equal degree, allowing the audience to see them equally well.

Give, take: When two actors are not equally *open,* the one who receives a greater emphasis is said to *take* the scene. The other is said to *give* the scene.

Upstaging: When one actor takes a position that forces the second actor to face upstage or away from the audience. Since the downstage actor is put at a disadvantage, *upstaging* has an unpleasant connotation and is generally to be avoided. You should take positions on the exact level of the actor with whom you are playing. Neither intentionally nor unintentionally upstage another actor unless you are directed to do so.

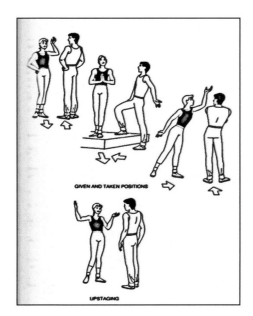

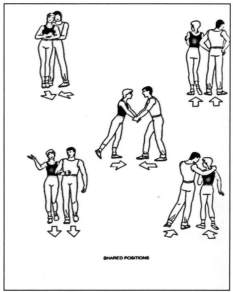

These positions of sharing are for proscenium and arena stages. Remember the general note about full back on a proscenium stage; although, the convention has loosened up, it is still not appropriate for characters to speak upstage for long periods. There are more terms for the actor's positioning on stage in the Appendix section of this text.

Work Cited

Feldenkrais, Moshe. *Awareness Through Movement.* New York: Harper-Collins, 1990. Print.

Bibliography

Mitchell, Theresa. *Movement from Person to Actor to Character.* Lanham, Maryland: Scarecrow, 2009. Print.

Adrian, Barbara. *Actor Training the Laban Way: An Integrated Approach to Voice, Speech, and Movement 1st Edition.* New York: Allworth, 2008. Print.

Hall-Karambé

*Uttering a word is like striking a note
on the keyboard of the imagination.*

Ludwig Wittgenstein

Chapter Three:
Influential Training

Influential Training: A form of intuitive training, student actors practice the art of being perceptive to characters' innermost desires through the use of voice and diction (phrasing). Student actors practice vocal dexterity and interpretation of monologues and scenes using the acting component of voice. Students must illustrate, vocally and descriptively on the text, that they understand the meaning of the creative pieces they are performing. The goal is to learn that the characters' emotional state influences vocal interpretations, which in turns influences the audiences' emotional reaction. The voice communicates the inner world of the psyche to the outer world of attentive listeners both on stage and in life.

The Influential Voice

The actor's instrument is in its entirety—the body, voice, and mind. They are one being, yet they are separate entities; hence, the training for them differs. There will be overlaps, and that is fine because the idea is that they will ALL overlap—eventually. For now, however, the point is to explore each entity as an isolated and specialized region. Although the voice is part of the body, the training for it differs from the training method of the physical body; even though, it does, subsequently, subjectively benefit from the kinetic training. Think of vocal training as another form of isolation. Like with the other regions of the body, isolations were done to explore the grouping's physical range, while illustrating the duality sublime-grotesque/beautiful-ugly nature of that particular part of the body for example, the perfected spinal alignment of a dancer and the curved bump of a hunchback. This notion holds true with the voice as well. Through vocal exploration, the artist's works to improve upon his/her vocal quality and impulse response with the goal being that, in performance, he/she uses the discoveries to give authentic voice to the character being played. That is not to say that the actor is programmed to follow a vocal formula; quite the

contrary, the process aims to guide the student actor towards a better understanding of his/her instrument. The artist, in doing so, becomes more open vocally to the emotional and psychological urges that occur during his/her portrayal of a character. Most importantly, the voice should reflect the character's struggles or victories; it is a voice that is natural for the character and situation and not "put on" for affect. An affected voice is hollow; the vocal quality is strained and emotional depth is surface. When the words are spoken, they don't ring true to the audience's ears. They are not moored to any real emotional center or chakra.

While the first chapter dealt with the Kinetic component of K. I. P—the body—this chapter deals with the Influential component—the voice. The Influential voice is what we strive for in the system because it is persuasive, effective, and musical in its quality; it can be powerful at times and whimsical at others. An influential voice coaxes the audience persuading them to listen and to listen careful to the ideas of the play—the character's reasons for being—so they might share in the experience of the character's emotional and mental state. The influential voice is, simply put, important for the student actor to develop because it allows him/her to freely express the character's innermost impulses and/or thoughts completely and without hesitation. As Kirsten Linklater writes in *Freeing the Natural Voice*, an actor's goal is to develop:

> ...[a] voice that is in direct contact with emotional impulses,
>
> shaped by the intellect but not inhibited by it. Such a voice
>
> will be a built in attribute of the body. It will have an innate
>
> potential for wide pitch range, intricate harmonies, and
>
> Kaleidoscope textural qualities and will be articulated in

clear speech response to clear thinking and desire to

communicate (6).

A student actor's pursuit is for a voice that has those qualities. However, the voice, like the body, is often overlooked and only thought about when it is inflamed and sore. The voice is fragile; it can be weakened and damaged from misuse. Often, vocal weaknesses stem from various factors that lay behind the terms: environmental, spiritual, intellectual, and physical. Each of these factors can work for or against the voice's communicative abilities. When the voice is unhealthy, it becomes ineffective, distorted, and uncontrollable; at that point as an instrument for the actor, it becomes unusable. The student actor's goal is to develop an influential voice; one that is free to explore and illustrate the inner emotional impulses and intellectual nuances of the body and brain and not be barred by the physical or mental hindrances of those former terms. We work the voice so that it is liberated from such tensions in order to operate in its full capacity.

What does the term *influence* mean when referring to the human voice? It means to effect, sway, and/or inspire someone to do or see something or someone more clearly or differently. For the voice to influence an audience, it must have the power to guide them into the mind of the character and world of the play. The influential voice opens the audience's psyche disturbing their very being and leading them to catharsis. As Linklater states, "...the voice of the actor should be the most potent theatrical element by which the light of a cathartic event illuminates the dark places, hidden stories, or pent-up emotions of the audience (8)." In other words, the actor leads the audience through the character's life,

Hall-Karambé

and in doing so, the audience travels the character's path—feeling what she does, knowing what she knows (and sometimes even more), sharing her *life*—at a safe distance.

In order to achieve such an influential voice, the actor must be free of tension, relaxed but prepared to experiment. Just as the body has to prepare for performance so must the voice. Warming up the body is the first step to preparing for vocal work. Simply put, when freeing the body, the physical entity housing the voice, of tension, the voice is also liberated, freed to explore as both an instrument of human interaction and as an artistic tool. Working with vocal warm-ups and drills, students aim to improve upon their craft. The goal of the influential voice is to be flexible in nature in order to express human "emotion, complexity of mood, and subtlety of thought" (Linklater, 8). The voice works with and separate from the body, and like the body, it can and will betray the artist. It must be protected from the elements and the stresses of life. It doesn't get enough rest because it is the primary way we communicate with the world. When exploring the elements of what makes an influential voice, student actors begin to develop such instruments that would allow them to tell the tales of William Shakespeare, Wole Soyinka, Tennessee Williams, or Edgar Allan Poe with depth and clarity striving to communicate the intent of the author to the fullest. Therefore, the need to develop such an influential voice is vital to the actor's work in communicating to an audience. A voice that is free of tension with proper breathing and breath, articulation and diction skills, and interpretation abilities are all marks of an influential voice.

The Physicality of the Voice

The voice can be a powerful tool when used properly, and like other physical aspects of it can be improved upon with training and practice. But how does the voice actual work? The physiology of the voice is quite simple to understand, and each component is vital to the process working properly and to its fullest potential. Let us begin by looking at the physical components that go into producing vocal sound. In order to produce the most basic of sounds, a person must have these organs. They make up the respiratory system:

- Lung(s)
- Vocal cords/ Larynx
- Sinus passages
- Esophagus
- Mouth/Oral cavity
- Brain
- Diaphragm
- Ears

Human Respiratory System (Male & Female)

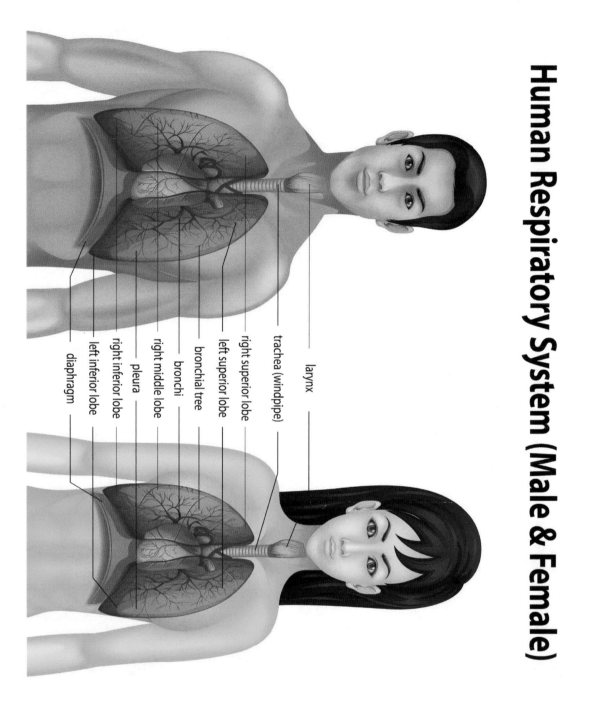

larynx

trachea (windpipe)

right superior lobe

left superior lobe

bronchial tree

bronchi

right middle lobe

pleura

right inferior lobe

left inferior lobe

diaphragm

Sinus passages

Each of these items has its own individual function, but when in concert with the others, they become one of the actor's most powerful tools. Without those physically connected organs, the respiratory and auditory systems would not function in a natural manner. The combined respiratory-auditory system is a natural stereo providing the artist the means to bring humanity's significance and consideration of life to focus in ways that are colorfully musical and often compelling.

Hall-Karambé

The body is nature's stereo. It is built to project sound over a distance; it is built for resonance. Let us examine the basic parts of a stereo system; they are a transmitter, an amplifier, and speakers with voice coils. It should be noted that for these purposes, these parts, interestingly enough, correlate with areas of the body, particularly the sections of the torso, neck, and head. For example, the brain is the transmitter; the ears are the receiver; the larynx is correspondent to the voice coils, and the chest, pharyngeal, and nasal cavities are the speaker parts. When human beings need to produce a sound, the brain transmits impulses to the lungs and the larynx or the voice coils, which converts air into sounds and words. The sound and word produced resonates and is projected from the chest, pharyngeal, and nasal cavities by air from the lungs, which is supported by the diaphragm.

Low-frequency sound is produced in the chest cavity much like a sub-woofer, and mid-frequency sound is produced in pharyngeal cavity like a woofer, while high-frequency sound is produced in the nasal cavity similarly to a tweeter. The diaphragm is a dome-shaped muscle that supports the breath by flattening on inhalation (expanding) and curving during exhalation (contracting). It can force air out of the lungs quickly or allow it to easy out slowly. The diaphragm aids in volume and projection of the instrument through its accordion-like action. The ears of the listener and speaker pick up the sound that is produced by this action. Through this simple description, it becomes easier to imagine the body as a stereo system that produces sounds transmitting them to the listener.

So what is the proper way to breath to maximize the body's natural resonance? That depends on the need for the scene being played; however, in studio, student actors must

sharpen their vocal capabilities in order to free them from the similar constraints that hold the body hostage. They must bring their breath to the forefront of their consciousness to get to a point of being able to "develop the ability to observe without controlling (Linklater, 22)." Physical, emotional, and mental tension can limit vocal capabilities causing student actors to think that the voices they hear everyday are their natural voices. The physicality of the voice is made up of several different parts that work together in order for humans to make sound, and like the body, most people don't think about their voices until they have pain or lose them. The general public doesn't concern themselves for the most part with training the voice. In contrast, for an actor, vocal training is essential because it is not only about the sound produced by the actor but way words are pronounced as well, and good vocal training can assist in obtaining vocal clarity and articulation skills.

Vocal clarity and articulation skills are important for the student actor to develop because they allow the meaning of the playwright's words to resound with truth; that clarity, however, is only found through the correct articulation of the playwright's language. Clarity is being defined here not only to mean clearness of sound but the clear transmission of thought and/or idea. If the actor's articulation is indistinguishable, his/her voice as well as the playwright's is hindered in meaning and limited in scope. Much like our primitive relatives who grunted, "oo-ed" and "ah-ed" discovered, the sound produced by the body remains primitive until given depth with articulation. What is articulation? Articulation is, in a nutshell, the "formation of the individual sounds of a language (Wells, 17)." Returning to our primitive relations, it is not hard to imagine that the sounds they first produced were the most basic vowel-like noises.

This condition could remain for only a few thousand years, for as humans moved up their evolution ladder, their sound production and need for clarity did as well. In others word, their need to understand the unintelligible sounds of their mate hasten the development of language. Language development was the answer for early humans' need to understand each other in the most accurate way. Therefore, our ancestors' oral cavities changed to accommodate the need to articulate.

Language is a tool to express ideas, feelings, and information; human beings' need to understand and to be understood is rooted in our survival instincts. As they evolve, early humans underwent physiological changes—descended larynx, changes to the sub-oral cavity and tongue—that permitted more fully developed speech. The formation of a well-developed oral cavity permits modern humans to articulate words effectively; the parts of the oral cavity that aid in the clarity of words are the tongue, teeth, jaw, and soft palate. These are collectively known as the articulators. Their actions and shapes contribute to speech sounds'—vowels and consonants—tonal characteristics. Working in concert together, the articulators form the crispness of consonants while giving depth to vowels tones. In other words, the "Ts" are not "D" sounding and "Oos" have space to expand increasing or decreasing in volume.

As student actors learn to feel their breath and are no longer conscious of the physicality of breath, their brain activity, resulting from impulses of thoughts and feelings to be expressed, naturally regulates various activities in the vocal tract. Moreover, the body gauges how much air to inhale by the complexity of the thought to be expressed, the intensity of the emotion, and the communication needs of the situation.

Vocal Terms and Warm-ups

These are just a sampling of vocal terms and the warm-ups. They will help you to gain more in depth knowledge about this particular area. The vocal terms are ones you will hear in class, in rehearsal, and on set, so learn them and what they mean and do. Remember, when it comes to the vocal warm-ups, the only way to get better at these is to practice them everyday.

Vocal Terms

Breathing: The process of inhaling and exhaling air and, in this context, utilizing that air for producing voice.

Resonation: The amplification of vocalized sound that occurs in pharynx, nasal cavities, and oral cavity.

Articulation: The formation of the individual sounds of a language.

Pitch: The perception of highs or lows in tonal quality, which is determined by frequency of the sound's vibration.

Inflection: A change in the pitch either higher or lower than the previous sound. It can be a single vocalization, and sometimes there are multiple variations in a vocalization.

Intonation: Movement pattern of vocal pitches that characterizes a language or a person's speech.

Variety: The consciousness use of inflection, upward and downward pitches, to avoid monotone, dull speech and to gain an emotional response.

Loudness: The degree of intensity given to vocal sound. Interchangeable with volume.

Projection: The ability to support the voice placement appropriate for the room and distance the vocal production has to travel.

Stress: It has two meaning that depend upon the context spoken. 1). If the voice is tired, overworked, or strained due to too much intensity, or 2). particular emphasis given a word or phrase in a sentence or speech.

Duration: The time of spoken and silence in language.

Rate: The number of words per minutes.

Pause: A brief break in speech characterized by silence.

Speech phrasing: An idea or a group of words that form a meaning unit and are surrounded by pauses or beats.

Syllabic stress: When emphasis is given to a syllable.

Quality/timbre: That characteristic of vocal sound determined by resonance. There are several qualities: nasality, denasality, breathiness, gutturality, stridency, thinness, hoarseness, harshness, and raspiness.

Articulation: Positioning the articulators to create the sounds of language.

Pronunciation: Proper utterance of a word as it is currently used.

Dialect: Variation of articulated language characterized by phonemic choices, grammar, vocabulary, syllabic stress, rhythms, and inflections.

Vocal Warm-ups

These vocal were not created by myself but are from my own training, workshops, and professional sets.

1. Yawning Tones/Staccato Tones/Long Tones

In this warm-up drill you will yawn out, shorten, or lengthen the sound. To yawn a sound, you start by opening the mouth wide. Stretch out your whole face; lift your eyebrows and allow your jaw to drop open. Yeah, you are going to look like a nut, but so is everyone else. Be sure not to let the voice get caught in the throat; you should always push the sound forward through the nasal passages as well as the mouth. You can put any letter at the beginning of the vowel.

a. Ma, mee, mo, mu

b. Tha, thee, tho, thu

c. Pa, pee, po, pu

d. Ba, bee, bo, bu

e. Ca, cee, co, cu

f. Za, zee, zo, zu

g. Na, nee, no, nu

h. Da, dee, do, du

i. Ka, kee, ko, ku

j. Pa, pee, po pu

Variation #1: To work breath and strengthen the diaphragm, you make the sound staccato or short for each word.

Variation #2: Again working with breath and diaphragm, you lengthen or hold the tone for a count of 2, 3, 4, and so on until completing a count of 8 each word.

Variation #3: Allow the voice to play with the sound by inflecting the tones from high pitch to lower pitch and using increasing (crescendo) and decreasing (decrescendo) volume.

2. Counting to 30

In the exercise, you are to warm up the voice counting to 30 one breath. If you cannot make it to 30 comfortably then do not continue.

3. Reciting the Alphabet

Similar to counting to 30, you will recite the alphabet in one breath. If you cannot make it to "Z" comfortably then do not continue.

4. Arpeggios

Arpeggios are a series of note in a chord or in a key signature. In this exercise you do a series of arpeggios in various keys with and without the keyboard. You should go no higher or lower than what is comfortable to you.

5. Scales

Every person has a bottom (bass/alto) and top (tenor/soprano) vocal register; we speak in the middle of the range where it is most comfortable for us. Only in certain situations do we venture outside of our comfort zones; usually these shifts happen when we become excited, angry, or experiencing some emotional moment. However, for the public speaker having vocal flexibility is to his or her benefit. Vocal dexterity allows the speaker to put the mood in a performance because he or she has the ability to change his or her vocal quality.

Scales allow the performer to gain vocal dexterity because they train the vocal instrument to become more amenable therefore permitting the speaker to change the quality of their sound in an instant.

There are several ways to do scales properly; you can start at the bottom of your vocal register and move the pitch up higher and higher until your reach the top of you vocal and then you head down the same way. You should do this exercise on one breath, but you can work up to it if you can't in the beginning. Another scale method is to sing just an octave and then come back down. And yes, you are singing because it helps you to learn breathe control faster. This is not a music class so you will not be graded for your singing ability.

6. Rolling Rs

Just as the title states, you will be rolling the letter r around in your mouth. Make sure you move the tongue from the front (hard) of the platé to the back (soft) and back again. It is not easy, but it wakes the tongue up.

Rrrrrrrrrrrrrrrrrrrrrr (roll for 4 counts/ repeat several times)

7. Patter, Patter, Patter goes the Raindrops

This little exercise warms up the vocal machine (articulators and respiration) preparing it for the work ahead. You should keep the pace and rhythm of the piece. It should accelerate with every round.

Patter, patter, patter goes the raindrops, raindrops

Patter, patter, patter on the windowpane.

Patter, patter, patter goes the raindrops, raindrops

Patter, patter, patter on the windowpane.

Patter, patter, patter, patter, patter, patter, patter, patter, patter, patter, patter on the windowpane.

Patter, patter, patter, patter, patter, patter, patter, patter, patter, patter, patter on the windowpane.

Hall-Karambé

Variation #1: Do the limerick again, but this time, you should give the lines different inflection variations.

8. Variation of Emphasis

You are to say each sentence stressing the highlighted word.

1. **I** didn't say she liked him!
2. I **didn't** say she liked him!
3. I didn't **say** she liked him!
4. I didn't say **she** liked him!
5. I didn't say she **liked** him!
6. I didn't say she liked **him**!

9. Barrel House Kings

In this exercise, you should try to achieve round tones and vocal flexibility.

In a flat, black box,

In a round barreled room,

Barreled house kings with feet unstable,

Shagged and reeled and pounded on the table.

Pounded on the table?

Beat an empty barrel with the handle of a broom

Hard as they were able,

Boom, boom, boom,

With a silk umbrella and the handle of a broom.

Boom-a-lay, boom-a-lay, boom-a-lay, boom.

10. Wibbleton to Wobbleton

From Wibbleton to Wobbleton is 15 miles.

From Wobbleton to Wibbleton is 15 miles.

From Wibbleton to Wobbleton, from Wobbleton to Wibbleton,

From Wibbleton to Wobbleton is 15 miles.

11. Tongue Twisters

Tongue twisters have always been a pleasure and pleaser among people. We love to hear someone speak the twister well and correct, but even more so we love to see the slip up the tongue.

➢ Six sick slick slim sycamore saplings.

➢ A box of biscuits, a batch of mixed biscuits

➢ A skunk sat on a stump and thunk the stump stunk,
 but the stump thunk the skunk stunk.

➢ Peter Piper picked a peck of pickled peppers.
 Did Peter Piper pick a peck of pickled peppers?
 If Peter Piper picked a peck of pickled peppers,
 where's the peck of pickled peppers Peter Piper picked?

➢ Red lorry, yellow lorry, red lorry, yellow lorry.

➢ Unique New York.

Hall-Karambé

➢ Betty Botter had some butter,
"But," she said, "this butter's bitter.
If I bake this bitter butter,
it would make my batter bitter.
But a bit of better butter--
that would make my batter better."

So she bought a bit of butter,
better than her bitter butter,
and she baked it in her batter,
and the batter was not bitter.
So 'twas better Betty Botter
bought a bit of better butter.

➢ Six thick thistle sticks. Six thick thistles stick.

➢ I slit the sheet, the sheet I slit, and on the slitted sheet I sit.

➢ She sells seashells by the seashore.
The shells she sells are surely seashells.
So if she sells shells on the seashore,
I'm sure she sells seashore shells.

➢ Mrs. Smith's Fish Sauce Shop.

➢ "Surely Sylvia swims!" shrieked Sammy, surprised.
"Someone should show Sylvia some strokes so she shall not sink."

➢ A Tudor who tooted a flute
tried to tutor two tooters to toot.
Said the two to their tutor,
"Is it harder to toot
or to tutor two tooters to toot?"

Hall-Karambé

12. Practice Emotional Inflection

Say each sentence in the list below with a different emotional inflection and see how it can change the meaning of the sentence. This is a good exercise to do with a friend or relative.

Sentences:

1. I am so exhausted I could fall asleep right here.
2. This is the most beautiful view I've ever seen.
3. I am certain that I told Harry what time to meet us.
4. Well, well, well, what have we here?
5. My uncle is the best racecar driver ever.
6. Where will we go now?
7. I can hardly wait! We're going to Disneyland.
8. Go away! I never want to see you again.
9. I know, you've only told me twelve times already.
10. My favorite pet fish Ferdinand died.
11. Look out for that falling rock.
12. We'll never make it.

Emotions:

Excited, Sleepy, Tired, Sad, Impatient, Angry, Scared, Resentful, Sarcastic, Bored, Confused, and Powerful

Practice Speech

This speech will be used to warm-up ours instruments and as analysis material as well. It would behoove you to spend some time with it on your own.

Shakespeare's "Speak the Speech…" from *Hamlet,* Act 3, Scene 2

Hamlet: Speak the speech I pray you as I pronounced it to you,

trippingly on the tongue; but if you mouth it as many of your

players do, I had as lief the town-crier spoke my lines. Nor do not

saw the air too much with your hand thus, but use all gently; for in

the very torrent, tempest, and, as I may say, whirlwind of your

passion, you must acquire and beget a temperance that may give it

smoothness. Oh, it offends me to the soul to hear a robust

periwig-pated fellow tear a passion to tatters, to very rags, to split

the ears of the groundlings, who for the most part are capable of

nothing but inexplicable dumb-shows and noise. I would have such

a fellow whipped for overdoing Termagant — it out-Herods

Herod. Pray you avoid it.

Be not too tame neither, but let your own discretion be your

tutor. Suit the action to the word, the word to the action, with this

special observance, that you overstep not the modesty of nature.

For anything so overdone is from the purpose of playing, whose

end both at the first and now, was and is, to hold as it were, the

mirror up to nature; to show virtue her own feature, scorn her own

image, and the very age and body of the time his form and

pressure. Now this overdone, or come tardy off, though it make the

unskillful laugh, cannot but make the judicious grieve, the censure

of the which one must in your allowance overweigh a whole

theatre of others. Oh, there be players that I have seen play, and

heard others raise and that highly, not to speak it profanely, that

neither having the accent of Christians nor the gait of Christian,

pagan, nor man, have so strutted and bellowed that I have thought

some of nature's journeymen had made men, and not made them

well, they imitated humanity so abominably.

Oh reform it altogether. And let those that play your clowns

speak no more than is set down for them, for there be of them that

will themselves laugh, to set on some quantity of barren spectators

to laugh too, though in the meantime some necessary question of

the play be then to be considered. That's villainous, and shows

a most pitiful ambition in the fool that uses it. Go make you ready.

Hall-Karambé

Work Cited

Linklater, Kristin. *Freeing, The Natural Voice.* Hollywood: Drama, 2006. Print.

Well, Lynn K. *The Articulate Voice: An Introduction to Voice and Diction, 4th Edition.* Boston: Pearson, 2004. Print.

Through my eyes films

ഇന്റെ

*We know what we are but
not what we may be.*

*Ophelia in **Hamlet***

ഇന്റെ

Chapter Four:

Psychodynamic Training

Hall-Karambé

Psychodynamic Training: Psychodynamic is the interaction of motivational forces that affect behavior and mental states of the person (character), especially on a subconscious level. It examines the reasoning why people do the things they do based on archetypal notions.

The Psychodynamic Character

I regard the theatre as the greatest of all art forms, the most immediate way in which a human being can share with another the sense of what it is to be a human being.
Thornton Wilder

Theatre is the arena of plays and players; it allows the participants, including those viewing, to experiment with ways of being human. Theatre's, the arts in general, most subtle intention is "its ability to mediate our psychological shortcomings and assuage our anxieties about imperfection (Jung 3)." There must be conflict in theatre, for it is central to the art form. As the character struggle to attain their desires, theatre allows the audience to live out fantasies and fears, victories and defeats without the consequences of real life circumstances. Art counterbalances our innate weaknesses of the mind; weaknesses that

can be refer to as mental and/or spiritual frailties. The interaction and interplay between actors—text/symbols, and actors—audience leads to catharsis. Catharsis, according to Aristotle, is the purging of emotions; a more modern interpretation of the word would be that it is when the character or audience member goes through some analytic process or has some type of psychoanalytic revelation that permits them to grasp the mystery of their desires. This mental—emotional breakthrough and the following release are what the actor strives for in performance and what the audience has

Hall-Karambé

come to witness and, in some cases, participate. Therefore, part of theatre's function is to teach us about ourselves illustrating what is means to be human. To quote Shakespeare's Hamlet when speaking to the players about how to play characters, he states the responsibility of the actor is…

> *"…both at the first and now, was and is, to hold as it were, the mirror up to nature; to show virtue her own feature, scorn her own image, and the very age and body of the time his form and pressure* (**Hamlet**, Act 3, Scene 2) ."

Therefore, the job of the actor is to show humanity at its best and worst; it is an actor's job to show the nature of humans in order for the lessons being brought forth to be comprehended and understood by those witnessing the event. Actors are in charge of creating a character from the words on a page. These pages and words are often lacking in the solid substance needed by the actor to create character or so it seems. As I often tell student actors, 'the playwright only gives you the bare bone. You as an artist must provide the muscle, breath, and heart of the character.'

What is the psychology of the mind when it comes to acting? How does a student actor comprehend this vague allusive concept? How does it work? In other words, what are concrete ways student actors can use to get into the mind of their character in order to portray them as accurately as possible? In the KIP System, it is taught

ဆၣ

All the best performers bring to their role something more, something different than what the author put on paper. That's what makes theatre live. That's why it persists.
Stephen Sondheim
ဆၣ

that an actor must have an understanding of psychology—a basic understanding of human consciousness and sensitivity—to delve into a character's mind. The methodologies towards understanding the acting notion of 'getting into mind of the character' are the beginning steps toward developing character when dealing with realistic plays. There several psychological skills that help an actor create his/her characterization; one of the first is learn to interpret the symbols.

Symbols in Theatre

Theatre is symbolic in nature and function; therefore, it would be appropriate that in order to produce theatre soundly one must be an interpreter of symbols. For actors, it is important that they can understand, recognize, and interpret the symbols and symbolic ideas and clues given by the playwright and connect those with their archetypal observations, human history, and basic human emotions or empathy. Most student actors believe that acting is just about remembering the lines, but that becomes difficult when you do not understand that the words are symbols that stand for even more deep meaning than often perceived at the first reading. Symbols as well as symbolic ideas and clues guide actors into the mental and emotional world of characters. Symbols for the actor in are the words the characters say, the historical setting of the play, and thematic ideas and images put forth by the playwright. Therefore, it is of most importance that student actors understand what they, as characters, are saying at all times.

Symbols are all around us, but in most cases, we don't see them clearly and honestly as we could. That lack of vision maybe due to our own cultural/social bias;

"Man . . . never perceives anything fully or comprehends

anything completely. He can see, hear, touch, and taste;

but how far he sees, how well he hears, what his touch

tells him, and what he tastes depend upon the number

and quality of his senses. These limit his perception of

the world around him (Jung 4)."

Human beings are often hindered in growth and understanding by their *Weltanschauung*. What is *Weltanschauung*? It is a particular philosophy or view of life; it is the worldview of an individual or group. Our worldview encroaches on how we see the world and the people it. Through evolution, human beings developed it to protect themselves from the delicacies of being human and as a bonding agent for the people as they banded to form clans, tribes, or ethnic groupings. For example, during past centuries when humans met people of a different group, their basic human curiosity allowed them to be inquisitive, but their worldview would alert them to be weary of the unknown and to take note of the dissimilarity. *They have similar qualities as us, but they do, act, and/or look different than us.* If that sense of caution remains strong about the other, it could eventfully cause them to form negative ideas about the differences between them and the people who possess those traits. This scenario has been played out through the centuries as different people met, clashed, dominated, and, in some cases, obliterated others in order for their worldview to reign superior. Our *Weltanschauung* enables us to make quick snap judgments about a situation and it rooted in our sense of survival. Nevertheless for student actors, they must learn to look pass and through their worldview particularity if it is hindering their progress as an artists. When they automatically place judgment on an individual or a group without

Hall-Karambé

taking the time to seek out the basic human commonalties we all share to find the universal humanity, their visions and characterizations are then blinded and flawed because, instead of seeing the whole person, they only see is the individual's or group's perceived flaws. Therefore, it becomes imperative that when student actors when make observations, they do so honestly and recognize that they maybe hindered by *their own* cultural/social bias and prejudices.

It has been stated that words are symbols, but there are other things that can be and are symbolic that an actor must look out for when preparing a character. Characters' cultural trappings are symbols that point to ethnic background, while word choice or vocabulary might indicate education background. Actors can also look for symbols in the play's location and names of character and places. Actors must also look at the historical symbols and aspects as well because no playwright works within a vacuum. What was happening during the time the play takes place? How does historical symbols play out in the play? Thus symbols help the actor get into

Exercise 1: Symbolic Interpretation

Poetry and lyrics are full of symbolic language. Look at the following passage from a popular song by Billie Holiday and highlight the words that stand out to you. Then explain in your own words the subtextual and historical references.

Strange Fruit

Sung by Billie Holiday
Southern trees bear strange fruit
Blood on the leaves and blood at the root
Black bodies swinging in the southern breeze
Strange fruit hanging from the poplar trees
Pastoral scene of the gallant south
The bulging eyes and the twisted mouth
Scent of magnolias, sweet and fresh
Then the sudden smell of burning flesh
Here is fruit for the crows to pluck
For the rain to gather, for the wind to suck
For the sun to rot, for the trees to drop
Here is a strange and bitter crop

Hall-Karambé

subtext—the underlying meaning of the characters' words—as well as the world of play itself.

Observing Others: Archetypal Characters and the Development of Character

Acting, at its most basic, is an imitation of archetypal ideas about human nature. Archetypes are typically characters that seem to represent universal patterns of human beings. Jung argued that the root of an archetype is in the "collective unconscious" of mankind. The phrase "collective unconscious" refers to primal experiences shared by humankind. These include love, fear, death, birth, life, struggle, survival etc. Although these experiences can be culturally and socially specific on the conscious level, they exist in the subconscious of every individual for we all know what it is to have loved, lost and everything in between. It is these shared universal ideals that are recreated in art forms. Archetypes are cross-cultural with no one ethnic or cultural group having a monopoly on any type. Although, there are those who will say otherwise, but that is when an archetype becomes a stereotype. For example, we all have seen the archetypal "drunkard/drug addict," "clown/fool," "artist," "brainy/nerd," "dimwit," "loner," etc. in every ethnic group and culture. The student actor must work not prescribe certain traits to a particular group but understand that every culture has its fair amount of each archetype; otherwise, they will be guilty of playing a stereotype thus making their performance shallow and surface.

In acting training the first thing an actor must do is learn to be is to be a nonjudgmental observer of the world, a historian of such, yet, instead of writing volumes, the actor's body and vocal expressions becomes the canvas to illustrate the nature of

Hall-Karambé

humans and time. Thus, when an actor takes on a character, he/she is striving to tap into the primordial unconsciousness of humans in order to see the world from that character's point of view. This ability to observe without judgment aids the student actor in understanding what others are thinking, feeling, believing, and desiring. Again, to understand the archetypal nature of human beings, student actors must learn not to judge another but to examine them in an objective manner in order to clearly see the individual. Through nonjudgmental observation, they notice the basic mechanics of an individual person: gait/movement patterns, speech patterns, thought patterns, etc. These are thing that they can take back for use in building a character.

"Lysistrata, Cross your Legs Sistah!" by Ardencie Hall-Karambe, Ph.D. Musical adaption by Ardencie Hall-Karambe, Ph. D. based on *Lysistrata*, by Euripides. Scenic Design by Petre "Teddy" Moseanu; Costume Design by Ardencie Hall-Karambe, Ph.D. and Rhonda Davis. Community College of Philadelphia, 2014.

Acting Project I: Character Observations

<u>Specifics:</u> The Character Observations aid student actors to identify from their observations basic human traits that can become the bases of building characters.

1. For observations, student actors must observe someone they know without his/her knowledge. Choose someone that you see on a regular basis. Don't tell that person he/she is the subject of your study. People will alter their behavior to appear "better" people.

2. In your observations take note of the basic physical and vocal characteristics of the individual. Students should make mental and written notes of the encounters. Don't embellish; just observe and report what you see and hear.

2. Using the subject's words, student actors must develop monologues.

3. Student actors must perform 1:30-2:00 minute Character Observations based on their notes. They must exhibit the physical and vocal qualities of the observed in order to illustrate and create basic characters. If you are observing a family remember, it becomes doubly hard to find the differences in physical and voice traits in many cases. Blood is thinker than water; therefore, you must really look for the unique things that make family members individuals in their own right.

4. Student actor may use only one hand prop.

After compiling and completing the observation, student actors should fill out the following form to the best their abilities. You must be like a detective to uncover the nuggets of personal history without letting the subject know you are digging for information.

Acting Project I

CHARACTER OBSERVATION FORM

1. Play Title: _____ **2. Character's name:** _____

3. Brief Overview of Situation:

4. Overview of Character:

 A. Name: _____

 Sex: _____

 Age: _____

 B. <u>Marital status:</u>

 <u>Personal history:</u> (Include only what is necessary for the performance)

 C. <u>Educational level:</u>

 D. <u>Economic:</u> (poor, middle-class, rich, etc.)

 <u>Social status:</u> (How are they viewed in community in which they live?)

 <u>Profession:</u>

5. Describe the character: Physically, Emotionally, and Verbally

Observations are the building blocks of characters for the actors. By observing others, student actors begin to gain insight to the human condition and humanity in general. Observations teach us about archetypes and when combined with different individual characteristics or traits, actors can then begin to build a character unique and complete.

Once the student actors take on a script, however, the observation mode changes and their observations must be based on what they have read in and interpreted from the script as well as their archetypal reflections. Therefore, it becomes important for the actor to do an analysis of the character in the play. The following is a character development form. This form is to be used by the actor to aid in the development of character. It provides space for the actor to layout a visible sketch of the character's physical and mental state of being. Actors must know every aspect of the characters they are playing but playwrights often do not give much of the information. This is where the actors' creativity and imaginations comes into play. Through the process of creating the Character Development Form, student actors will have to explore, discover, and decide on various aspects of the personalities and motives of the characters they portray.

Character Development Form/ GOTE—sheet

1. Play Title: **2. Character's name:**

3. Brief Overview of Play:
 Give a summary of the play's storyline.

4. Overview of Character: External, Internal, and Environmental
- **External Aspects**

 A. Name: _____
 Sex: _____
 Age: _____

B. Marital status: Is the character married or single? How does this situation affect his/her life?

Personal History: What kind of life has he/she led? What is the character's home life like? What has lead them to this point in life?

C. Educational level: What is the character's level of education? Does the character desire education? Why or Why not? How is education viewed in the world of the play?

D. Economic: What is the character's occupation? What is the character's class status?

Social status: What is the character's social status in the play's world? How are they viewed in community in which they live?

5. **Describe the character:** Physically, Emotionally, and Verbally.
Is the character athletic, fat, physically handicapped, emotionally weak, passive, aggressive, etc?
Does the character speak as an educated, ghetto, street, or country person?

- **Internal Aspects**

6. **Goal: The goal should be something quite specific and outgoing.**
What is the character's objective or motivation?
What does the character really want?
What is the character's intention?

7. **Obstacle: The obstacle is the other person(s) with whom, for whom, or from whom the character seeks their goal.**
What is the obstacle for the character?
Why is the other standing in the way?
What are the character's deepest fears?

8. **Tactics: Tactics are the character's means of trying to achieve their goals; they are what give acting its guts.**
How does the character go about getting what he/she want?
What tactics does he/she display? How can the character get it?
Who can the character threaten or give pleasure to get it?
Who can the character induce to get what he/she wants?

9. **Expectation: Expectation is what the character hopes to achieve upon getting his/her goal. It gives tone, spring, and excitement to the dramatic pursuit of goals and quest for victory.**
What does the character expect in the end?

Hall-Karambé

Why does the character expect to get it?

What is it about the conquest that thrills or excites the character?

What will the character do when they get it?

10. What one word adjective best describes the character?

- **Environmental View**

11. What do the other characters in the play say about the character?

12. Draw or find a picture (can be an object or human personae) of the character. Explain why this object or person reminds you of the character.

13. Describe the environmental conditions of the character.

This modified form is based of the work of Robert Cohen from his text *Acting One,* as well as other theorists, and goes by the acronym of GOTE—sheet, which stand for goal, obstacle (other), tactics, and expectations; in combination, these are four coordinates that form the actor's view of the character's internal struggle. The GOTE—sheet, is the actor's basic list of questions whose answers will create the foundation for approaching a specific character. They are a necessary part of the process because they cause actors to think of the character as a living being, and just all living beings have been influenced by the past so has the character. The actor must determine certain events in the character's life that may have some bearing on their current situation. The material on the GOTE is not accessible to the audience, and, in many cases, or to the director but the actor knows and uses it to build a foundation upon which the character can stand. I tell students: "Imagine what you life would be like if you had no memories. The GOTE—sheet allows you to "create the memories" of character.

Hall-Karambé

ℬ⟩℘

Acting is taking a text usually written by someone else and investing your personality, intelligence, interest in other people, and emotions to create a character that is *living in the situation* of the play as if it is real and true at that moment.

Robert Cohen

ℬ⟩℘

Scoring a Script

It is becoming easier to see how acting goes beyond just memorizing the lines, and how it is clearly obvious that the actor must engage with the script in an intimate way. Hence, when you score your script, it will aid you in that respect. Remember, words have multitudes of meaning; however, when strung together, the connective neighbors reveal the truth of the situation as they band together to form a literary image in the mind's eye of the speaker and the listener. According to Carl Jung in his masterpiece, *Man and His Symbols,* "[m]an uses the spoken or written word to express the meaning of what he wants to convey. His language is full of symbols (3)." Therefore one of the steps to getting in the mind of the character is to comprehend about what he/she means when speaking. The actor, working as symbolist, must identify the symbols in the text that affect the character's thinking and behavior. As an audience member, there is nothing more frustrating than to see that the actor (as character) has no idea what he/she is discussing or trying to convey. It thins out the illusion of the play.

Coming from the world of music, musical compositions are called scores because the markings indicate how the music is to be played. Theatre scripts do not contain these types of signals, and therefore, it is the actor's job to do so for his/her character. Student actors

mustn't be afraid to do the homework of the actor. With close examination of the script, they open themselves up to the subtle nuisances of what characters are saying which leads to insight into the characters' underlining reasoning or subtext for saying those words in the first place. Those words, however, must be taken in context and viewed as part of the world of the play. Jung again on the importance of symbols writes: "What we call a symbol is a term, a name, or even a picture that may be familiar in daily life, yet that possesses specific connotations in addition to its conventional and obvious meaning (3)." Another way is to say that depending on the situation, the meaning of words change, and, therefore, it is within the context of the play that the words begin to make sense to the actor. When that happens, he/she can then begin to memorize, to find the rhythm, and to express the meaning of the lines. The way the actors handles these changes is vitally important for depending on how they gave nuance the words will determine the way that the playwright's meaning and the director's intent are interpreted by the audience. Part the of the actor's homework is, consequently, to score the script in order to dissect the pieced and to discover the musicality hidden there.

To score a script, the student actor takes on the job of diagramming the sentences much like a student sitting in an English learning the structure of sentences. Just like those grammar students, student actors seek out the grammatical aspects, but they take it one step further by look for the musicality of the words, sentences, and entire work. The scored script in the end looks a lot like a sheet of music. The student actor marks it with dynamic scoring, which indicates the how the piece is to be performed.

Hall-Karambé

Exercise 2: Symbol Identification

One looks at music and it seems as if it is a different language. It is! It is a language of symbols and those trained in it can tell you what the markings mean. For this exercise you must transcribe the code symbols shown. Examine the music sheet to the left. What marking do you see? Write or draw the symbols on a separate page. Next, you will use the Internet to look up the meanings of the marking. For your search, you should start by looking under "musical symbols."

Once you have scored the script, you should include a key that will remind you of what the markings mean. Also when someone else is looking at your scoring, he/she will be able to follow your thought process as you break down the character's words. The following is a sample monologue taken from Shakespeare's *Hamlet*. Remember that the scoring of a script is highly subjective to the actor's interpretation of the role. Therefore, score the text the way you think it should be in order to play well using the ideas in the above insert as well as these musical notations.

Acting is a very personal process. It has to do with expressing your
own personality, and discovering the character you're playing through
your own experience - so we're all different.

Ian Mckellen

Scoring a Script: A Simple Methodology

Once you have found a script, you should score the script to aid in understanding the meaning if the scene.

1. *Underlining*: of major points, of important or forceful statements

2. *Vertical lines in the margins*: to emphasize a statement already underlined.

3. *Circling of Key words or phrases.* If a word is unknown, look it up.

4. *Writing in the margin, or at the top or bottom of the page, for the sake of:* recording questions (and perhaps answers) which a passage raised in your mind; reducing a complicated discussion to a simple statement; recording the sequence of major points right through the monologue/play.

5. *Highlight changes of mood.* Highlighters are an actor's friends. Using the different color available, the color can indicate the characters in mood/emotion the character is experiencing.

Musical Notations transferrable to Theatre Scoring:

	Bar Line: Slightly different than the straight line in music, but idea is the same. The separation of thoughts between lines indicating a change in thought.
	Bar Line: In this case, this bar line not only indicates a change of thought but change in pacing.
{ }	**Bracket**: Connects two or more lines of text that corresponds in idea or thought.
	Inflection: Indicates voice inflection going up. Questions are prime examples: "Are you going to the store?"
	Inflection: Indicates voice inflection going down. Statements are prime example: "The day is dark and dreary."
	Crescendo: To increase in volume.
	Decrescendo: To decease in volume.
,	**Breath Comma**: Used above the line to indicate take a breath.
//	**Caesura**: Used to indicate a pause or silence where time stands still.
B	**Beat**: Used to indicate a moment of contemplation and thought.
PP	**Pianissimo**: Very soft.
P	**Piano**: Soft.
MP	**Mezzo Piano**: Literally, half as soft as piano.
MF	**Mezzo Forte**: Half as loud as forte.
F	**Forte**: Loud.

FF	**Fortissimo:** Very Loud.
⌒	**Phrase Line:** Drawn over lines to indicate one complete thought spoken without breaks for pauses or breath.

These are sample scoring-symbols, and there are others that can be used. You just need to remember to include a key explaining what they mean.

Exercise 3: Scoring a Script

In this exercise, you must score this speech. Please utilize the markings given.

Shakespeare's "What a piece of Work is Man" from *Hamlet*:

Hamlet: I will tell you why; so shall my anticipation

prevent your discovery, and your secrecy to the king

and queen moult no feather. I have of late--but

wherefore I know not--lost all my mirth, forgone all

custom of exercises; and indeed it goes so heavily

with my disposition that this goodly frame, the

earth, seems to me a sterile promontory, this most

excellent canopy, the air, look you, this brave

o'erhanging firmament, this majestical roof fretted

with golden fire, why, it appears no other thing to

me than a foul and pestilent congregation of vapours.

> **What a piece of work is a man!** how noble in reason!
>
> how infinite in faculty! in form and moving how
>
> express and admirable! in action how like an angel!
>
> in apprehension how like a god! the beauty of the
>
> world! the paragon of animals! And yet, to me,
>
> what is this quintessence of dust? man delights not
>
> me: no, nor woman neither, though by your smiling
>
> you seem to say so.

Acting Styles: Representational and Presentational Acting Styles

Before concluding this chapter, it is important to briefly mention presentational and representational acting styles because as a working actor you will need to know how the styles differ. Presentational acting styles are used when dealing non-realistic scripts—be those classical or experimental. These styles are not worried so much about the psychology of the character because in many cases, especially in the case of Shakespeare, the character is already telling us what he/she thinks. The conventions of the time prescribed the actor's performance: asides, soliloquies, apron-playing and speaking directly the audience. Some of these conventions were taken up by modern theatre artists like Bertolt Brecht, Augusto Boal, and others to use in various ways to bring experimental and certainly political ideas into a seemingly stale and extremely structured unimaginative theatre environment.

Representational acting style is used with realistic or naturalistic scripts. Coming at turn of the 20th century, realistic plays by Anton Chekov and Henrik Ibsen along with the work of Sigmund Freud caused the need for a new acting style to be discovered. Here, in representational acting, we are worried about the subtext—what is below the text— or the undercurrent of character thought.

Konstantin Stanislavski and his Moscow Art Theatre took on the work to develop as style of acting that answered to all the change in theatre convention at the time. His style of acting is what Uta Hagan is called "The Method." In Stanislavski's approach, by the time the actor reaches the stage, he or she no

Representational Performance Innovators and Styles:
Bertolt Brecht Epic Theater Vsevolod Meyerhold Erwin Piscator Joan Littlewood and Theatre Workshop Augusto Boal and Theatre of the Oppressed Dario Fo and Franca Rame Shakespearean Theatre Restoration Comedy

longer experiences a distinction between his or her self and the character; the actor has created a 'third being', or a combination of the actor's personality and the role. There are, however, different schools of thought about acting mostly based on Stanislavski.

Presentational Performance Innovators and Styles:
Constantin Stanislavski Stanislavski's 'system' Method acting Meisner technique André Antoine Otto Brahm J. T. Grein Naturalism Psychological realism

Conclusion: The Actor's Ego

The average person believes that to be an actor must possess a huge ego, and some actors do have HUGE EGOs. However, on average their egos are no large than most, yet is it important to

discuss ego if the psychology of acting is being explored. Let's begin with a clear definition so that we are working on the same page. Ego according to Dictionary.com is a noun that...

1...identifies the "I" or self of any person; a person as thinking, feeling, and willing, and distinguishing itself from the selves of others and from objects of its thought.

2...comes from Psychoanalysis and is the part of the psychic apparatus that experiences and reacts to the outside world and thus mediates between the primitive drives of the **id** and the demands of the social and physical environment.

3...describes a person's egotism; conceit; self-importance:

Her ego becomes more unbearable each day.

4...that gages self-esteem or self-image; feelings:

Your criticism wounded his ego.

5...is used in Philosophy and speaks to the enduring and conscious element that knows experience. Scholasticism is the complete person comprising both body and soul.

6...is used in Ethnology and describes a person who serves as the central reference point in the study of organizational and kinship relationships.

Again as stated earlier, words can have a lot of meanings; for our purposes, although several apply I would like to begin by exploring numbers 1, 2, 4 and 5. These definitions focus on the individual's ego, his/her internal way of dealing in the world, but they also go

beyond and include the individual's ability to have empathy for others and encompasses the "both body and soul" of the person. Therefore, for student actors, an important lesson for them to learn is that their feeling of empathy for the characters' ordeals doesn't mean that they agreed with the choices the characters' make. The actor's ego must be set aside to permit the other to come through. The differences between people can be largely based on the choices they make. It is those choices that lead us to a point or place. It is same for characters, and the actor cannot allow himself/herself to get caught up by placing judgment on the character's choices in comparison to what his/her actions would be. In most cases, they are not same choices the actor would have made, but the actor must be able understand and see why the character made those choices. In analyzing a script, the actor must mark and see the character's choices that have lead him/her to this point in the play. When a student actor understands that it is not about him/her, he/she are able to reach a deeper understanding of the character and can play the character more truthful, more honestly. This is accomplished during rehearsal process when the student actor is working to bring the physical and mental foundational aspects of the character together. This in turn allows them to move from the foundation the Actor's Pyramid to the core area called the Risk region. Why risk? Well it is simply because the actor is somewhat or completely free of the script (i.e. memorization) and is able to begin playing out the character IN the play's world. They begin to experiment with what they have written on the page to see if it stands true in the play's reality. The actor strives during this time to find the core of the character. In doing so, they operate as the character would in that world and do things they normally would not do. They act outside of themselves, and they begin to find the things that make that character unique and more solidified which then allows them to rise to the

top of the pyramid. Throughout this text, it has been the objective to explain in the most basics of terms an approach to acting and, specifically, the K.I.P. System. The next step is to take this theory and test it out during the rehearsal process, for it is then that it is all—kinetics, vocal, and psychodynamic—brought together.

Work Cited

Jung, Carl G. *Man and His Symbols*. New York: Dell, 1964.

ഔരു

Seventy-five percent of great art is hard work only about twenty-five percent is great talent.

Lee Strasberg

ഔരു

Chapter Five
Theatre Terminology

Hall-Karambé

Theatre Terminology: Terms, Definitions, and Lingo

It is not only important and necessary for the actor to understand and comprehend everything about the play they are interpreting, but it is also important that the actor understands that theatre is a profession and a place to work. As such, the theatre has its own vocabulary that is used by people in the business. Actors, therefore, are expected to become familiar with this language and use it when working in the theatre.

Directors and acting coaches will expect you to know the terms and lingo because they will use them during rehearsals and in classroom situations. Think of the terms and lingo as a form of short hand that is used by people in the theatre to communicate ideas, concepts, and directions for the play. Refer to the list of terms, definitions, and lingo often for it will be helpful in understanding what is expected of you as an actor in rehearsal and in performance. Remember that this is just a beginning list of terms, and there are others to learn as well.

Stage Directions

Blocking: The director's arrangement of the actor's movement on stage with respect to one another and the stage space. It is the plotted movement of the actors on stage. Blocking is used to tell the story, develop characterization, set mood and atmosphere, and create suspense.

Stage right: The actor's right as he stands onstage facing the audience.

Stage left: The actor's left as he stands onstage facing the audience.

Downstage: The area of the stage closet to the audience.

Upstage: The area of the stage furthest away from but visible to the audience.

In: To turn in toward the center of stage.

Out: To turn away from the center of stage.

Upstaging: Means to turn away from audience making it hard to hear and see the performer(s).

Stage Areas

UR	URC	UC	ULC	UL
R	RC	C	LC	L
DR	DRC	DC	DLC	DL

AUDIENCE

These abbreviations stand for the 15 stage positions: up right, up right center, up center, up left center, up left, right, right center, center, left center, left, down right, down right center, down center, down left center, down left. When a director is blocking, she will ask to actor to move to the various playing areas of the stage floor. The actor should memorize the stage areas very well.

Onstage: The part of the stage, usually enclosed by the setting and visible to audience during any particular scene.

Offstage: All parts of the stage not visible to the audience.

Backstage: The entire stage portion of the theatre building, in contrast with the auditorium, which is designed as *out front*.

Wings: Offstage space at the right and left of the acting areas.

"Juxtaposition" Written and Directed by Ardencie Hall-Karambe, Ph.D.
Scenic Design by Petre "Teddy" Moseanu. Costume Design by Ardencie
Hall-Karambe, Ph.D. Community College of Philadelphia, 2007.

Stage Movement

Cross: Movement from one area to another. When noting a cross in your script, the standard abbreviation is X.

Counter cross: A movement in the opposite direction in adjustment to the cross of another actor. The instruction usually given is *counter left* or *counter right*. If only a small adjustment is necessary, the actor should make it without being told.

Hall-Karambé

Curved cross: In crossing to a person or an object above or below you, it is necessary to cross in a curve so you do not arrive either upstage or downstage of the person or object. Sometimes called an **arc** cross. (Follow the curved lines in the illustrations.)

Cover (A): When another actor moves into a position between an actor and the audience, thus obstructing him from view. Covering usually is to be avoided. Generally, an actor is expected to observe these practices:
1. The responsibility is on the downstage actor. In other words, do not stand in front of another actor.

2. If another actor does stand directly below you, make a small adjusting movement.

3. Since a moving actor usually should receive attention, make crosses below other actors so you are not covered. This rule does not apply if the moving actor should not receive attention.

Cover (B): A term used to define the speech or action invented by a actor to keep the audience from detecting a mistake.

Dress stage: A direction requesting the actors to adjust their positions to improve the composition of the stage picture.

CURVED CROSSES

Stage Business

Small actions, such as smoking, eating, slapping, falling, telephone, crying, using a fan, and tying a necktie are known on the stage as *business*.

Properties

Business often involves the use of properties. Props, as they are commonly called, are divided into several categories.

Hall-Karambé

Hand props: Small objects the actors handle onstage, such as teacups, letters, books, and candies.

Personal Props: Hand props that are carried on the actor's person and are used only by him—such as watches, spectacles, and cigarette holders. An actor is usually responsible for taking care of his personal props during rehearsals and performances.

Costume Props: Costume accessories used by the actor in executing business—fans, walking sticks, gloves, and handbags, for example.

Stage Props: Objects for dressing the stage not used by the actors in executing their business. Vases of flowers, lamps, clocks, and bric-a-brac might be stage props.

Prop table: Tables that are usually places offstage right and left to accommodate props the actors carry on and off the set. The property master and the stage manager are responsible for placing props on the tables, but a careful actor checks his props before each performance. It is the actor's responsibility to return immediately to the table all props he carries off the set.

Lines and Dialogue

Ad lib: Coming from the Latin *ad libitum* (at pleasure), the term applies to lines supplied by the actor wherever they may be required, as in crowd scenes or to fill in where there would otherwise be an undesirable pause.

Aside: A line that the other actors onstage are not supposed to be hearing. The aside was a regular convention in plays of the seventeenth, eighteenth, and nineteenth centuries, but it is rarely used by modern dramatists.

Build: To increase the tempo or the volume or both in order to reach a climax.

Cue: The last words of a speech, or the end of an action, indicting the time for another actor to speak or act. An actor should memorize his cues as carefully as he memorizes his lines.

Pick up cues: A direction for the actor to begin speaking immediately on cue without allowing any lapse of time. Beginning actors tend to be

slow in picking up cues, with the result that they often fail to maintain a tempo fast enough to hold the interest of the audience.

Tag line: The last line of a scene or an act. It is usually emphasized.

Overlapping or Telescoping: Overlapping speeches so one actor speaks before another has finished. It is a technique for accelerating the pace and building a climax.

Miscellaneous Terms

Action: That portion of an actor's part in a play defined by the pursuance of a specific goal.

Affective Memory: A term Stanislavski used to indicate both sense memory and emotional recall.

Apron: The part of the stage that extends toward the audience in front of the curtain. Also termed *forestage* or *thrust*.

Asbestos: The fire fie proof curtain that closed the proscenium opening and separate the stage from the auditorium in the case of fire.

Auditions: Reading of specific roles before the director to determine casting. In both the professional and nonprofessional theatre, plays are usually cast through auditions.

Back drop (see **drop**): The drop farthest upstage in any setting.

Backing: A drop or flats used outside an opening in the setting, such as a door or window.

Bit part: A small part with few lines.

Callboard: A backstage bulletin board on which notices of concern to the actors are posted.

Character part: Contrasted to **straight part,** role usually depicting an elderly, unusual, or eccentric individual.

Cheating: A term used without any derogatory meaning when an actor plays in a more open position, or performs an action more openly, than complete realism would permit.

Clear stage: A direction to leave the stage, given by the stage manager for everyone not immediately involved.

Company: A group of actors who perform together either in an individual play or for a season. Sometimes call a *troupe* or an *ensemble*.

Concentration: Giving complete attention to something. The ability to concentrate is a key part of effective acting.

Curtain call: The appearance of actors onstage after the performance to acknowledge the applause of the audience. Actors are required to remain in costume and makeup and to take the calls as rehearsed without variation. The term applies whether or not a curtain has been used.

Curtain line: The imaginary line across the stage floor that the front curtain touches when it is closed.

Dialogue: The lines spoken by the characters in a play.

Double: To play more than one role in a single play.

Drop Any material, ordinarily flown, used as backing for a scene.

Ensemble acting: A theatrical presentation in which the stress is on the performance of the group rather than the individual.

Exit: To leave the stage; an opening in the setting through which actors may leave.

Extra: A small nonspeaking part: soldiers, townspeople, ladies-in-waiting, and so forth.

Flats: The canvas-covered frames that constitute the walls of a stage setting.

Flies: The space above the stage in which scenery is suspended. Scenery coming from this space is said to be flown in.

Focus or Foci: A multi-changing word that could mean to focus one's attention or vision (view) on the scene at hand. It could mean on of the three focuses of the actor: onstage focus, offstage focus, or audience focus. In most performance the actor may use a combination of all three views.

Fourth wall: In an interior setting, the imaginary side of the room toward the audience.

Front curtain: A curtain closing the proscenium opening that hangs immediately behind the asbestos.

Given circumstance: Any unchangeable fact that affects the playing of the scene.

Green room: A room located close to the stage, in which the actors may await entrance cues and receive guests after the performance.

Gridiron: A contrivance located in the flies for suspending scenery.

Ground plan: The arrangement of doors, windows, steps, levels, furniture, and so forth for a stage setting; also a diagram showing the arrangements. The director usually explains the ground plan at an early rehearsal. Each actor should draw the diagram in his script.

Improvisation: Spontaneous invention of lines and business by performers.

Indicating: Performing an action without an intention. Indicating is a derogatory term in psychologically motivated acting.

Intention: The character's real reason for performing an action.

Justification: The process by which the actor directs his imagination to believe strongly in the reality of each stage action.

"Magic If": A term used by Stanislavski to describe the process by which an actor places himself in the given circumstances of the scene.

Motivation: Why the character acts.

Mugging: A derogatory term for exaggerated facial expressions.

Obstacle: A physical or moral obstruction that hinders one from completing an action.

Pacing: Although some directors attempt to distinguish between *pace* and *tempo*, for practical purposes they both mean the rate of speed at which the actors speak their lines, pick up their cues, and perform their actions—the length and number of the pauses. Pace is a subtle, and vital, element in a performance. Frequently heard directions are "Pick up the pace" or "The pace is too slow (or too fast)."

Places:
A direction given by the stage manager for everyone to be in his proper position for the beginning of an act.

Proscenium:
The wall dividing the stage from the auditorium.

This is a rehearsal shot from "Juxtaposition: A Fugue of Life and Death" by Ardencie Hall-Karambé presented at the Community College of Philadelphia. Rehearsals are very important to the actors; rehearsals are the chance for actors to workout stage bits or, in this case, a stage combat scene.

Proscenium Opening:
The arched opening in the proscenium wall through which the audience can see the stage.

Rehearsal:
Coming from the French word *repetition,* it means to practice repeatedly until done correctly. Directors use rehearsals to construct the world of the play with the actors during this time. They work on characterization, blocking, projecting, pacing, and a variety of different things. If there is no director, the actor takes on that role as well doing the same things the director does.

Run-through:
An uninterrupted rehearsal of a scene, an act, or the entire play. In contrast is the "working" rehearsal, in which either the director other actors may stop to work on details.

Stealing:
A director may ask an actor to steal: that is, he wants a movement that will not receive the audience's attention. The term is also used to mean taking the audience's attention when it should be elsewhere. Scene-stealers, either intentional or unintentional, are well-liked in any cast.

Straight part:
A role without marked eccentricities, normally a young man or young woman. See **Character part**.

Strike: The direction given by the stage manager to change the setting for another scene or to dismantle it at the end of a performance.

Subtext: The actor's continuous thoughts that gives meaning to the dialogue and the stage directions.

Trap: An opening in the stage floor.

Try-outs: Auditions.

Walk-on: A small part without lines; an extra.

Terminology for Non-Proscenium Theatres

Most of the terms on this list refer to stage movement and actor's position on one particular type of stage—the proscenium. In recent years, more and more theatres have moves toward other forms of staging such as *arena* or *three-quarter round* or *thrust* stages. Although, these stage types have been around for as long as theaters.

For staging in these spaces, acting areas are designated usually in one of two ways either according to the points of the compass or according to the hours of the clock. Therefore, actor will be asked to cross to "northwest" or to "ten o'clock." Such terminology works well in an arena space, but the thrust stage, which extends into the audience in various configurations, calls for more ingenuity on the director's part. A combination of the terminology used for the arena and for the proscenium stage usually will work for almost any space.

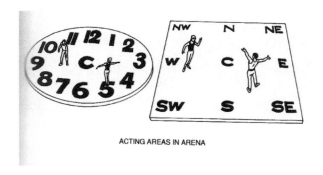

ACTING AREAS IN ARENA

Hall-Karambé

"Ain't Nobody...A Civil Rights Musical" Written and Directed by Ardencie Hall-Karambe, Ph.D. Presented by Kaleidoscope Cultural Arts Collective at the Dream-Up International Theatre Festival at Theatre for the New City in New York City, 2011.

Appendix

This section contains items, ideas, hints, and notions that the student actor will find good to know and necessary to advance their education in the theatre, their workplace experience on stage working with other cast and crewmembers, and their overall confidence in their art. Because theatre is as old as it is, it has many traditions that most novices are unaware. The following are areas for awareness that student actors need to know but didn't quite fit in the structure of the overall book. Yet, they are important for growth.

Did you know the term theatre means "the seeing place?" It comes to us from the Greeks.

Hall-Karambé

Preparing a Role

Choosing a Script: Simple Guidelines

When looking for a script, the student actor should remember certain guidelines:

1. Choose a character of the same gender unless you are willing to do a no-holds barred cross gender performance.

2. Choose a character no more than 10 years older or younger than yourself.

3. Choose a script you like and will enjoy working on for a while. Ones that you a personal interest in.

4. Choose a role with something happening in it, as opposed to a character relating something that has already happened.

5. Choose a role where you can identify with the character's struggle or dilemma

6. Choose a role where there is clearly something at stake, emotionally, for the character you will be playing.

The Rehearsal Process

Rehearsals are the opportunity to practice and develop the dramatic confrontation between your character and your acting partner's character.

Rehearse originally meant "re-harrow"—that is, to plow the field again. The French word for rehearsal is repetition. Thus rehearsal is a process by which you repeat your parts until they are learned-and until the lumps are broken down.

In a play production, rehearsals are und the control of the director. Ordinarily, the early rehearsals involve lectures or discussions on the play's meaning, the production concepts, and the development of the play's staging. In preparation for a classroom acting scene, ordinarily no individual controls the rehearsal; therefore, you and your partner must develop a working method together.

Rehearsals are reserved time on stage or in a performance space to work constructively on getting the play, scene, or monologue on its feet. The actors go through the piece as if it a performance.

Rehearsal Courtesies

An understanding of the courtesies required at rehearsal is critical to your training as an actor.

1. Your attendance at every rehearsal is critical. In the professional theatre, if you do not attend rehearsals, you are replaced (not paid) for the performance.

2. Be on time. In the professional theatre if you are late too many times, you are docked and, eventually, fired.

3. If you waiting in the studio or theatre while another actor is working, you should observe and concentrate on the happenings. Listen to whatever the director is telling the other performers, it might pertain to you as well. Do not visit with others in the studio or theatre. Do not interrupt the director while he/she is working with other performers.

4. The rehearsal process can be long and it can be boring, particularly, if you not on stage. Waiting and watching are inevitable in the rehearsal process and are part of the theatre project. Use your time productively to review your role and learn from your fellow performers by paying close attention.

Hall-Karambé

Decorum Guide

Courtesies of the Studio

Much of our learning in school is conducted in sterile classrooms where time is spent sitting and absorbing information and not much of the time is spent learning how to use the information in a practical sense. That is not the case in acting studios. It is always an honor and privilege to be in studio. These spaces are different from other classrooms and, therefore, the courtesies extended to others are different from those learning environments.

It is important to learn the courtesies and routines associated with studios. If you study in other studio spaces, you will know what is expected. Please, adhere to the studio courtesies at all times.

1. Always be early for call so you can change clothes and be ready to work when the class begins.

2. When you enter the studio, you should begin your personal warm-up. Studio space is a working laboratory.

3. Please do not talk when you or other students are working or performing. It is discourteous to speak when the instructor/coach is talking. In a studio, students are expected to remain focused at all time. Keep outside conversations outside once studio has begun.

4. Do not eat or chew gum during class or rehearsals.

Performances Types

In the KIP System, it is the students' jobs to perform certain types of theatrical performance. Student actors should learn to rehearse and to perform character observations, classical and contemporary monologues, movement and music experiments, and scenes. For most beginning students, however, they have no idea what these performances entail; therefore, the following descriptions of performances will come in handy to aid them in their process.

Descriptions of Performances: Character Observations, Classical and Contemporary Monologues, Movement and Music Experiments, and Scenes

Q.: What is a character observation?

A.: A character observation is an observed-rehearsed performance of an individual person who has been closely watched by the student actor; it is a basic observation-imitation type of performance. The observed person can be a family member, friend, co-worker, etc. but must be observable and communicative with the actor.

Q.: What is a monologue?

A.: 1. A monologue is a solo speech; the actor presents it alone on stage, and it is usually addressed directly to the audience, who becomes the second actor.
2. A dramatic (tragic or comic) soliloquy.
3. A long speech made by one person, often monopolizing a conversation.
(OED: Fr.: Gk. *mono-*, meaning one, + Gk. *–logos*, meaning speak)

Q.: What is a monologue performance?

A.: A monologue performance is presented by one actor. The actor may or may not use actual or realistic props, costumes, or furniture pieces. Monologue performances range in time from 2 minutes to 2 hours! For classroom performances, each monologue should be no longer than 2-5 minutes in length. Monologue performances are memorized presentations that are blocked (staged) and well-rehearsed.

Q.: What is a classical monologue?

A.: A classical monologue is a monologue from a play that is dated before 1900.

Q.: What is a contemporary monologue?

A.: A contemporary monologue is a monologue from a play that is date after 1900.

Hall-Karambé

Q.: What is a movement and music experiment?

A.: A movement and music experiment a simple exercise in kinetics. Students are to pick an everyday activity to perform to music.

Q.: What is a scene?

A.: 1. A scene is the presentation of a 5-10 minute cutting of a play performed by two or more characters.
2. A subdivision of an act in a dramatic (tragic or comic) presentation in which the setting is fixed and the time continuous.
3. A unit of continuous related action.
(OED: Fr. *Scène*, stage < OFr. < Lat. *scaena* < Gk. *skene*, tent, stage.)

Q.: What is a scene performance?

A.: A scene performance is a 5-10 minute cutting from a play that shows two or more actors presenting a continuous unit of dramatic action. The actors may or may not use actual or realistic props, costumes, or furniture pieces. For classroom performances, limit selections to one from a published play or novel that was made into a movie. Scene performances are memorized presentations that are blocked (staged) and well rehearsed. Each performer is evaluated separately and as a team.

Q.: What is a performance?

A.: To give a public presentation of a dramatic work, music, or any form of entertainment.
(OED: Lat. *per-*, per-) + *fournir*, to furnish)

Note:
Answers to the question: "What is performance," vary among different schools of thought. Some believe that anything can be constituted as performance while others firmly believe that only presentations of art and entertainment constitute performance. Both schools of thought, however, require that an audience (singular or plural) witness acts/performances.

Theatre Games

Theatre games are important to the actor's work. Through these exercises, actors learn much about themselves and tap into facets of being that they might not otherwise explore. Actors learn to explore the inside and outside of their personalities as well learn to communicate with others on the nonverbal levels. Theatre games allow us to think about humanity and human reaction in many different ways.

The following list of games is just an example of the many out there to explore.

Body Shapes:	Moving Centers of Being
	Joe Egg (aka trust circle)
	Colombian hypnosis
	Sound and movement wheels
	Mirroring (w/ variation)
	Minimum Surface Contact
Playing the Other and with the Other:	Bus Stop
	Eye (I) of a dream
Imagination:	Big Ball
	Environmental walking
Strategies:	Musical Chairs
Goal and Obstacle:	Reaching/Reaching for a Goal
	Overcoming an Obstacle
	Playing Tactics
	Expectations

Play to Read by Junior Year in College

Remember these are just a sampling of the plays.

Classical Greek:

Play	Author
Agamemnon	Aeschylus
Oedipus Rex	Sophocles
Medea	Euripides
Lysistrata	Aristophanes

Note: If you have time, you can check out some Roman authors as well such as Seneca.

Classical Japan:

Play	Author
Matsukaze	Kan'ami Kiyotsugu
Love letter from the Licensed Quarter	Anonymous

Note: If time permits, you should check out material on Sanskrit Drama and Theatre.

Medieval and Renaissance England:

Play	Author
The York Crucifixion	Anonymous
Everyman	Anonymous
Doctor Faustus	Christopher Marlowe
Hamlet	William Shakespeare
The Tempest	William Shakespeare

Early Modern Europe:

Play	Author
Life is a Dream	Pedro Calderón de la Barca
Tartuffe	Molière
Phaedra	Jean Racine
The Rover	Aphra Behn

Note: You should seek out some articles or books on commedia dell'arte.

Modern Europe:

Play	Author
Woyzeck	Georg Büchner
A Doll House	Henrik Ibsen
Miss Julie	August Strindberg
The Importance of Being Earnest	Oscar Wilde

The Cherry Orchard	Anton Chekhov
Major Barbara	Bernard Shaw
Six Characters in Search of an Author	Luigi Pirandello
Mother Courage and Her Children	Bertolt Brecht

The United States:

Play	*Author*
Trifles	Susan Glaspell
Ah, Wilderness	Eugene O'Neill
The Glass Menagerie	Tennessee Williams
Dutchman	Amiri Baraka/LeRoi Jones
Los Vendidos	Luis Valdez and El Teatro Campesino
Fefu and Her Friends	Maria Irene Fornes
for colored girls who have considered suicide when the rainbow was enuf	Ntozake Shange
True West	Sam Shepard
Fences	August Wilson
M. Butterfly	David Henry Hwang
Angels in America, Part I: Millennium Approaches	Tony Kushner
Anna in the Tropics	Juan Cruz

The World Stage

Play	*Author*
Waiting for Godot	Samuel Beckett
The Homecoming	Harold Pinter
India Song	Marguerite Duras
Travesties	Tom Stoppard
Death and the King's Horseman	Wole Soyinka
Cloud Nine	Caryl Churchill
Translations	Brian Friel

Note: You should read Antonin Artaud's *The Theatre and Its Double* and articles on Brecht's "Epic Theatre" Theory.

A native of Texas, Ardencie Hall-Karambe, Ph.D. is an associate professor of English/Theatre Arts at Community College of Philadelphia and is an avid professional artist. She has worked as a college professor, professional actress and director for 20+ years. Dr. Hall has a BFA in Acting and MA in Directing (emphasis in Musical Theatre) both from Texas State University, and a Ph. D. in Performance Studies from Tisch School of the Arts at New York University. As an actress, she performed in NYC at The Public Theatre, Theatre for The New City (TNC), P.S. 122 and other venues working with directors George C. Wolfe, Woody King, Crystal Fields and others. Ardencie has a passion for directing and has directed shows appearing at TNC (NYC), The Knitting Factory (NYC), Greenhouse Theatre (TX), and Community Education Center (PA). In 2008, she founded Kaleidoscope Cultural Arts Collective, which toured a musical she wrote entitled, Ain't Nobody...A Civil Rights Musical, for several years in and around the tri-state region finally landing in 2011 at the Dream Up International Theatre Festival (NYC) where is ran successfully with an offer to extend. Most recently, she adapted, scored, and directed "Lysistrata, Cross Your Legs Sister!" presented at Community College of Philadelphia in fall 2014. This production has been accepted to appear in TNC's 2015 off-off-Broadway theatre festival in the fall. A few years ago she teamed up with two partners and in January 2015, Dr. Hall et al launched Arden Blair Enterprises, LLC., a multi-service production company and are planning their coming theatre season. She has two blogs (which need more attention) one called "Thoughts on Theatre" can be found at http://divaarden.blogspot.com and the other "The Dharma Kitchen" at http://thedharmakitchen.org. Dr. Hall lives in Philadelphia with her son.

Photo Credits: Ardencie Hall-Karambe, Ph.D. and John Delancey, Jr.

Hall-Karambé

Made in the USA
Lexington, KY
06 October 2015